THE TOWNLEY MARBLES

B. F. Cook

THE TOWNLEY MARBLES

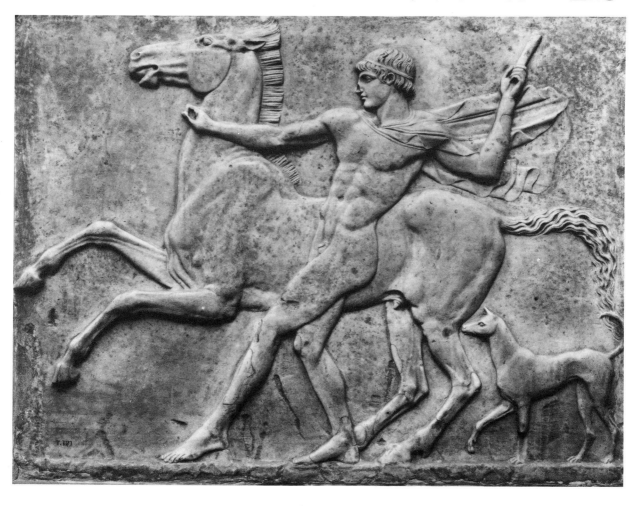

Published for the
Trustees of the British Museum
by British Museum Publications

© 1985 The Trustees of the British Museum

Published by British Museum Publications Ltd,
46 Bloomsbury Street, London WC1B 3QQ

British Library Cataloguing in Publication Data

British Museum.
 The Townley marbles.
 1. British Museum. *Department of Greek and
 Roman Antiquities* 2. Sculpture, Classical—
 England—London
 I. Title II. Cook, B. F.
 733 NB87.L6

 ISBN 0-7141-1279-8

Designed by Harry Green

Typeset and printed by the Pindar Group of Companies,
Scarborough, North Yorkshire.

Front cover Part of the dining-room in Charles
Townley's house. Detail of the watercolour by
W. Chambers. Collection of Lord O'Hagan. (See
also fig. 41.)

Page 3 Relief of a youth restraining a horse, copied
in the 2nd century AD from an earlier Greek relief.
(See also fig. 8.)

Contents

Preface

This account of the collection of marble sculptures assembled by Charles Townley is an expanded version of a lecture first given to the Association of Art Historians at their annual meeting in Manchester in 1982 and, in a revised form, at the British Museum to mark the opening of the new Townley Room in 1984. It could not have been written without the encouragement and goodwill of two of Charles Townley's kinsmen, Lord O'Hagan and Simon Towneley, to whom I am most grateful for permission to make use of documents and illustrations.

I am also indebted to Gerard Vaughan, who has worked extensively on the Towneley Papers, for reading my typescript, thus saving me from several errors, and for allowing me to quote some of the results of his own research: particular points due to him are indicated in the text by asterisks. Mr Vaughan and I hope eventually to collaborate in a more detailed work on Charles Townley and his collection.

My thanks are also due to John Kenworthy-Browne and Nicholas Penny; to the Bodleian Library (Department of Western Manuscripts), the Lancashire Record Office and Towneley Hall Art Gallery and Museums, Burnley; to the past and present members of my own Department who helped in various ways: W. H. Cole, A. W. W. Finnemore, Sheila Hayward, B. A. Jackson, I. D. Jenkins, Marian Vian and Susan Walker; and to A. P. Cowell, J. E. Hendry, and I. J. Kerslake of the Photographic Service.

Finally, since the Townley Room is but one of the Wolfson Galleries of Classical Sculpture and Inscriptions, I should like on behalf of the Trustees to record here the Museum's gratitude to Sir Leonard Wolfson and the Wolfson Foundation, whose generosity made it possible to transform the sculpture store-rooms into an exhibition space worthy of the collection and in this way to make a twelve-year dream come true.

B. F. Cook
Keeper of Greek and Roman Antiquities
December 1984

Charles Townley

Mr. Charles Townley, of Park-street, is universally admitted to have the finest collection of antique statues, busts, etc, in the world. They have been collected with the utmost taste and judgment, and may be seen by previously applying to Mr. Townley's to know the proper hour for admission.

The picture of London for 1802; being a Correct Guide to All the Curiosities, Amusements, Exhibitions, Public Establishments, and remarkable Objects, in and near London; with a Collection of Appropriate Tables. For the use of strangers, foreigners, and all persons who are not intimately acquainted with the British metropolis.

In the closing decades of the eighteenth century and the opening years of the nineteenth Charles Townley's collection of ancient sculpture, displayed in his house in Park Street (now Queen Anne's Gate), Westminster, was one of the sights of London. A water-colour of the hall by W. Chambers, painted in the early 1790s, although not entirely accurate in detail, still gives a good impression of the collection as it first met the eye of the visitor entering the front door (fig. 1). Like all the other principal rooms of the house, the hall was filled with sculptures. There were marble statues, busts and sarcophagi on all sides, and reliefs were mounted on the walls above them. In the left wall beyond the sculptures is the door to the street parlour, which contained a collection of terracotta reliefs as well as some marbles, and near it is the passage to the staircase and the dining-room, with the famous Discus-thrower at the end of the vista.

For those visitors not fortunate enough to be guided around the collection by Townley himself, a catalogue was provided with the sculptures in each room briefly described in sequence. A whole series of these catalogues, mainly written in Townley's own hand, was produced as additions to the collection or changes in the arrangement made earlier versions obsolete. Some are dated explicitly, approximate dates can be assigned to others by clues like dated watermarks and the presence or absence of key pieces like the Discus-thrower. Townley also kept private notebooks of purchases and related expenses, and compiled at various times lists of the sculptures by categories. These documents contain a wealth of information about the collection, where and when the sculptures were acquired and how much they cost. Collation of the room-by-room catalogues and comparison with contemporary illustrations also make it possible to reconstruct the arrangement of the rooms and the changes that Townley made over the years.

For the collection was not static either in content or arrange-

1 The entrance hall of Charles Townley's house in Park Street, Westminster. The statue of Ceres as Isis in the left foreground, the vases over the doorways and some of the reliefs on the left wall probably did not occupy these positions. Watercolour by W. Chambers, *c.* 1793. Collection of Lord O'Hagan.

ment: from his first purchase at the age of thirty until his death at sixty-seven Townley never ceased to acquire sculptures and to plan or execute changes in their display. More than half his lifetime was devoted to his collection, and in his approach to acquisition, to the restoration and exhibition of his sculptures, to their interpretation and documentation, Townley maintained standards that were fully

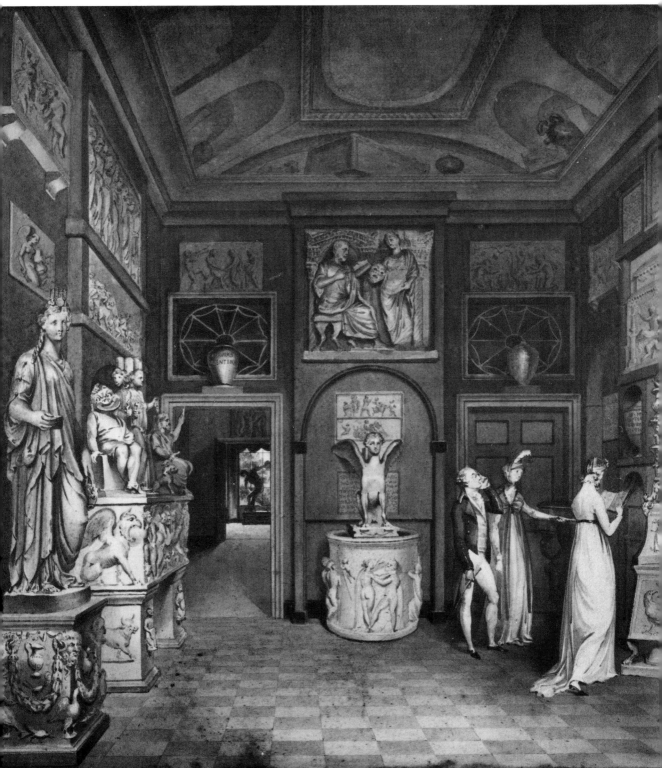

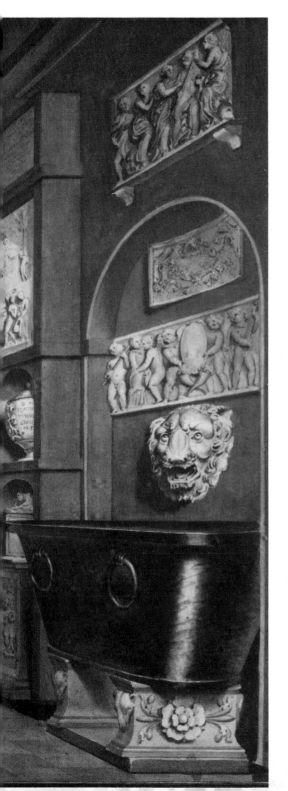

equal to those of the museum professionals of his own day and even for some considerable time afterwards.

Townley was born in 1737 and came from a distinguished Lancashire family resident at Towneley since at least the thirteenth century. His mother was the heiress to the nearby Standish estate, and her mother had been Lady Philippa Howard, daughter of the Duke of Norfolk. In the religious upheavals that followed the Reformation, the Towneleys, whose family motto is *Tenez le Vrai*, remained true to the old faith and paid the usual penalties for recusancy. They also remained loyal to the Stuart monarchy.

One of Townley's ancestors had fought with distinction at the battle of Marston Moor; two of his grandfather's brothers, having taken service under the French king, also served Bonnie Prince Charlie in the 1745 campaign. One of them, Francis, was appointed Governor of Carlisle, and after the capture of that city by the Duke of Cumberland he was tried for treason in London and executed on 30 July 1746. The other, John, who had been made a Knight of St Louis, returned to France and as the Chevalier Towneley lived in Paris, where he gained considerable repute for a witty translation into French of Butler's *Hudibras*. Charles Townley himself was sent to school at Douai and was later introduced by his great-uncle to Parisian society, where Sir Henry Ellis reported 'the gracefulness of Mr. Townley's person easily adapted itself to all the forms of polished address, so systematically taught in French society, from the dissipations of which it would be incorrect to say that he wholly escaped'.

Townley had succeeded to the family estate in childhood, his father having died in 1742, and about 1758 he returned to England to take possession of his inheritance. He took pains to improve the property and, as James Dallaway put it: 'During the first years of his possession, he joined in the athletic sports of the field, and partook of the boisterous hospitality for which the country gentlemen of that day, in the provinces remote from the Capital, were ambitious to distinguish themselves.' In 1767* he went abroad again, this time to Italy, and it was in Rome in 1768 that he acquired the nucleus of his collection of sculptures.

Collecting in Italy, 1768-1773

There was already a long tradition of collecting classical antiquities. In Italy this had been well established since the Renaissance, and it had been taken up in England in the seventeenth century. At that time most English collections consisted of small and easily portable antiquities such as coins, sealstones and bronzes, only a few particularly wealthy and powerful men being able to acquire sculpture in stone. These included Charles I and the Earl of Arundel, Townley's ancestor through his maternal grandmother. During the eighteenth century a new phase of collecting began in England, as ancient marbles were brought home as souvenirs of the Grand Tour. These new collections drew on two sources – the dispersal of some of the old Roman collections and new speculative excavations undertaken in Rome and its environs. Much of this lucrative

2 The most expensive of Townley's early purchases: a fragmentary marble group of two boys quarrelling over a game of knucklebones. The base, including the knucklebone and the 'broken' foot, is restored. H. 68 cm. *BM Cat. Sculpture* 1756.

3 Young faun or satyr with pan-pipes. Acquired by Townley from the Maccarani family, according to whose records the restoration of most of the arms and the lower legs was the work of Algardi (1602–54). H. 1.21 m. *BM Cat. Sculpture* 1647.

4 Marble cinerary urn with battles, acquired by Townley in 1768 from Amidei through Jenkins for £10. It was engraved by Piranesi and may have been made by him. H. 60.5 cm. *BM Cat. Sculpture* 2407.

trade was in the hands of Britons resident in Rome, notably Thomas Jenkins, Gavin Hamilton and James Byres.

Thomas Jenkins, who had been born in Rome in 1722, studied painting in London and returned to Rome about 1753. He was not successful as a painter but made a fortune dealing in paintings and antiquities, not all of which were genuine, as well as acting as banker for English visitors. He enjoyed the confidence of Pope Clement xiv (1769-74) and even served as unofficial representative of English interests in Rome. Many of Townley's sculptures were bought from him, at a total cost over the years of more than £5,000.

The collection began in 1768 with a flurry of purchases from the old Roman collections negotiated by Jenkins. By far the most expensive single item was a group of two youths quarrelling over a game of knucklebones (fig.2), which had been in the Palazzo Barberini since its discovery during the seventeenth century in the 'Baths of Titus', as the Baths of Trajan were then known. This group has been described as Townley's 'first important purchase'. One of the youths is biting the other on the arm, and since the victim has largely disappeared the sculpture was previously known as 'The Cannibal'. Townley records that the real subject was recog-

nised by Winckelmann after the hand was cleaned to reveal the knucklebone grasped in it. Winckelmann, the learned German art-historian who placed classical archaeology on a sound scholarly basis, went on to identify the sculpture with a group by the fifth-century Greek sculptor Polykleitos of two boys playing with knucklebones, which was mentioned by Pliny as being in his day in the Palace of Titus. This attribution is untenable today, but it accounts both for the reputation of the piece in the eighteenth century and for the eagerness with which Townley acquired it, an eagerness indicated by the price – £400, a huge sum in those days.

A receipt from Jenkins, dated 12 August 1768, preserved among a group of Towneley papers in the Bodleian Library, lists the Knucklebone-players along with other purchases, including statues of a Muse (also from the Palazzo Barberini) and of a young faun with a 'syringa' or pan-pipes (fig.3), busts of Nerva (fig.52), Trajan, Marcus Aurelius and Poppaea, a relief of a centaur with Deianeira, a circular urn with battles (fig.4), a sarcophagus ('engraved by Bartoli in Admiranda', fig.5), and a 'zampa', or table-

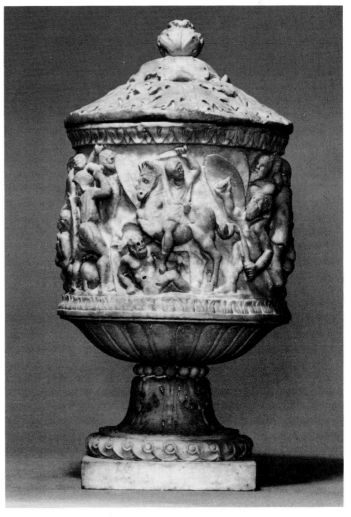

leg, in the form of a lion. Most of the items on the list can be identified, although not all of them were to remain in the collection.

Towards the end of the seventeenth century the 'sarcophagus engraved by Bartoli' was in the Palazzo Capranica, having previously been in the de Valli collection. The sarcophagus had also been published by Spon as early as 1683, and it was evidently well known as an illustration of a family mourning (*luctus domesticus*). None the less, in contrast to the £400 that Townley paid for the Knucklebone-players and up to £70 each for a series of second-rate portraits of dubious authenticity, the sarcophagus cost him only £20 – a telling comment on the value attached to sarcophagi decorated with reliefs as opposed to statues and busts.

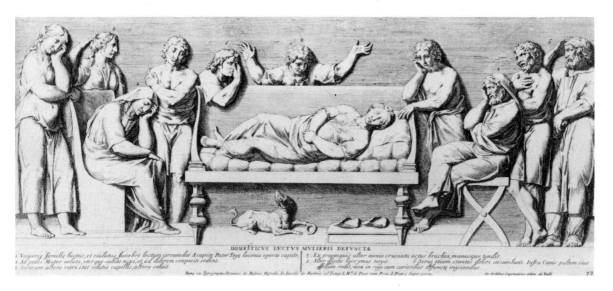

5 Sarcophagus showing a young girl lying dead on a couch surrounded by mourners, including her parents and other members of her family, as engraved by Bartoli in 1693.
BM Cat. Sculpture 2315.

The 'circular urn with battles' was acquired from Belisario Amidei, an antiquarian of the Piazza Navona, and is particularly interesting because it had been engraved by Piranesi (*Vasi, candelabri*, etc., 1778). As well as being a sculptor and engraver, Piranesi was active as a dealer in antiquities, some of which were restored in his own studio. A notebook in Charles Townley's hand, now in the possession of Simon Towneley, who has kindly allowed me to study it, records a number of purchases from Piranesi in 1768. They include a pair of Roman altars decorated with Egyptian figures, formerly in the Palazzo Odescalchi; an altar dedicated to Silvanus, from the Villa Burioni; a sarcophagus that had formerly belonged to Cardinal Passionei; and a fountain found a couple of years earlier between Tivoli and Praeneste by Nicolo la Piccola.

Another group of objects from the Villa Burioni was acquired by Townley in 1768 from Pietro Pacilli, an antiquarian who lived near S. Trinità de Monti in an area of Rome where antiquarians are still to be found. Pacilli also supplied Townley with a sculpture of Hecate formerly in the Palazzo Giustiniani (fig.6). It consists of three figures of the goddess, joined to each other at the back, and appears in Townley's manuscripts as *dea triformis* or Diana *triformis*. It was already a celebrated piece, the inscription on its base having been copied about 1600.

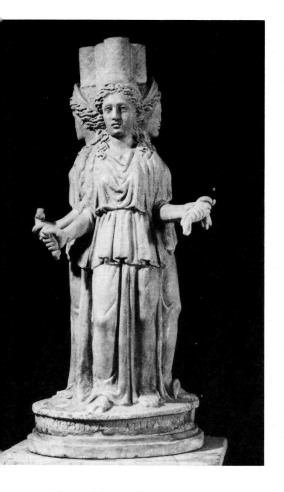

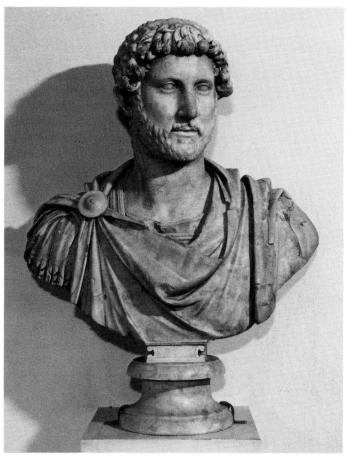

6 Statue of Hecate with an inscription recording its dedication by Aelius Barbarus, an imperial freedman, bailiff of the place where it was dedicated. H. 78.5 cm. *BM Cat. Sculpture* 1714.

7 Portrait bust of the Emperor Hadrian (AD 76–138), from Hadrian's Villa at Tivoli. H. 65.5 cm. *BM Cat. Sculpture* 1896.

Two other interesting sculptures were acquired through Jenkins in 1768, a portrait-bust of the Emperor Hadrian (fig.7) and a statue that had been found in October 1765 in the Villa Verospi at Rome, in what had been in antiquity part of the Gardens of Sallust. The statue was one of a pair, each showing a young woman seated on the ground, leaning on her left hand and playing at knucklebones with her right. The presence of a bow on the ground nearby suggests that the young women are part of the entourage of the goddess Diana: Townley himself referred to the statue as 'Diana recumbent'. It cost him £70.

The bust of Hadrian had been found some years previously, • perhaps as early as about 1740, in part of Hadrian's Villa at Tivoli belonging to Cavaliere Lolli, and it was on his death in 1768 that Townley was able to obtain it for £70. It was probably the first object that he acquired from Hadrian's Villa, a site that was to yield several important sculptures for his collection. In 1769 an excavation was begun there by Gavin Hamilton, a Scottish painter resident in Rome who collaborated with Jenkins and others in a series of speculative excavations. After an initial success in clearing out a lake known as the Pantanello, Hamilton came to a full stop when it seemed that Lolli had already cleared the rest. Fortunately, as Hamilton wrote later to Townley, Piranesi, who was waiting to

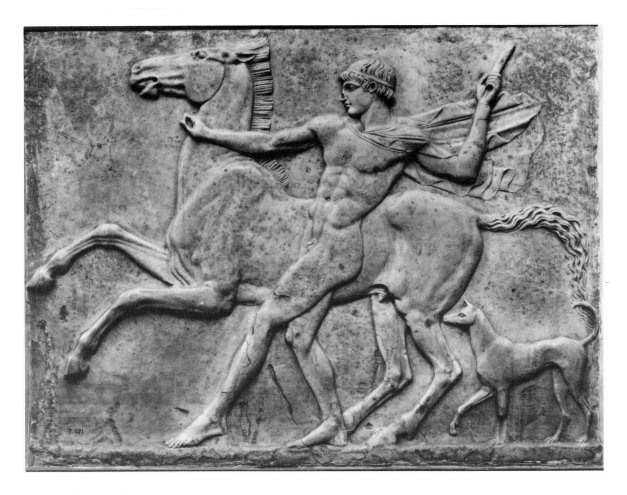

8 Relief of a youth restraining a horse, copied in the 2nd century AD from an earlier Greek relief, probably especially for the decoration of Hadrian's Villa, where it was found. H. 75 cm. *BM Cat. Sculpture* 2206.

hear Mass nearby, 'to fill up the time began a chat with an old man by name Centorubie, the only person alive that had been witness to Lolli's excavations and had been himself a digger'. Piranesi promptly introduced the old man to Hamilton, and after appropriate refreshment they went together to the site where 'Centorubie pointed out the space already dug by Lolli & what remained to be dug on this occasion, which was about two thirds of the whole'. It was probably in this place that Hamilton found in 1770 an elegant relief showing a young man with his horse and dog (fig.8). Townley, who later acquired it through Piranesi for £40, sometimes called it 'Castor and his horse'.

Meanwhile Townley's purchases of 1768 were crated and shipped to England in that year and the next through the port of Leghorn, the detailed arrangements being made by Jenkins. In a notebook now in the Lancashire Record Office at Preston (deposited there with other papers from Towneley Hall by Lord O'Hagan) Townley recorded expenses incurred in London during 1770 'for freight duties and all charges for cases from their leaving Leghorn to their delivery at Whitehall'. The first part of the Townley collection had arrived in London.

Expenses recorded in the notebook belonging to Simon Towneley show that in January 1772 Charles Townley was in Bologna, *en*

14

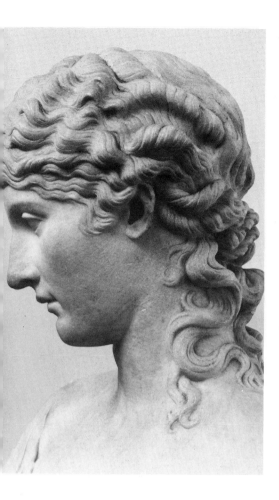

9 Bust known as 'Clytie', sometimes described in Townley's manuscripts as 'Bust like Agrippina ending in a sunflower' or 'Isis in the flower of the Lotus'. H. 57 cm. *BM Cat. Sculpture* 1874.

route for Rome, where he arrived towards the end of February, having spent some days in both Florence and Siena. In May he went to Naples, from where he paid a brief visit to Taranto. Returning to Naples, he bought from the family of Principe Laurenzano what was to remain one of his favourite sculptures, a marble bust of a woman emerging from a calyx of leaves, sometimes called 'Clytie', the nymph who pined for love of Helios and was turned into a flower, a name by which she is still affectionately known in the British Museum (fig.9). Modern scholars usually see in her a portrait of a Roman lady, perhaps Antonia, the daughter of Mark Antony and mother of the Emperor Claudius.

A few critics roundly condemn the head as an eighteenth-century forgery, but a more moderate and informed opinion is that it is an ancient piece, extensively reworked in the eighteenth century. The sculptor Nollekens, who also considered the bust to be a portrait, used to keep a marble copy in stock for sale. Townley's own regard for the piece was demonstrated in 1780 when, as the fury of the Gordon Riots was, in Dallaway's words, 'especially directed against the Catholic inhabitants, Mr. Townley participated in the general alarm. His house in Park-street having been marked by these destroyers, he withdrew in haste, apprehending their immediate attack. He had secured his cabinet of gems, and was taking, as he then feared, a last view of his marbles, when he seized the bust above-mentioned, and hurried with it to his carriage'.

In Naples Townley also met Sir William Hamilton, the English Ambassador to the Kingdom of the Two Sicilies, who in 1772 sold to the British Museum his first collection of antiquities, chiefly bronzes and vases collected in Naples and southern Italy. Townley returned to Rome at the beginning of February 1772 and remained there until almost the end of the following year. During this period Jenkins supplied him with a number of important sculptures, including a statue of a goddess with the attributes of both Demeter and Isis. The pail (*situla*) in her left hand and the disk flanked by serpents on her coronet identify her as Isis; but the disk is surmounted not by the feathers that Isis usually has but by ears of corn appropriate to Demeter. These two goddesses were frequently assimilated in the second century AD. In the Chambers watercolour (fig.1, left foreground) she is shown in the hall, but Townley's manuscript catalogues show that her place was long in the street parlour although she was eventually moved to the dining-room. Most of the later Townley manuscripts state that she was acquired from the Palazzo Maccarani, but an earlier reference gives the Palazzo Gabrielli.

In the centre of the Chambers watercolour (serving as a pedestal for a sphinx) is a cylindrical well-head (puteal) that Townley acquired through Jenkins from the Palazzo Colombrano in Naples. His willingness to pay a relatively high price for a relief sculpture (£50) was doubtless influenced by the mildly erotic character of the subject – Hercules and satyrs assaulting various women and a youth.

Among the sculptures recovered by Gavin Hamilton from the Pantanello at Hadrian's Villa was a striking bearded head that also came to Townley through Jenkins for £200 (fig.10). It appears in the Townley manuscripts under various titles 'Head of a Titan',

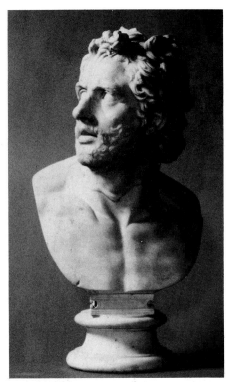

10 Head of a companion of Ulysses, excavated in Hadrian's Villa at Tivoli by Gavin Hamilton and acquired through Jenkins for £200. H. 58.8 cm. *BM Cat. Sculpture* 1860.

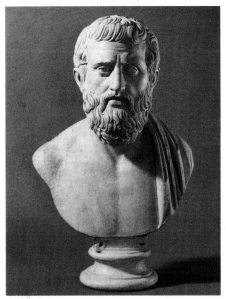

11 Head of a poet, perhaps Sophocles, but believed by Townley to represent Homer. Acquired from Jenkins in Rome for £50. H. 49.5 cm. *BM Cat. Sculpture* 1831.

'Head of Diomedes and or Ajax' or 'Head of a Hero Unknown'. Taylor Combe, the British Museum's first Keeper of Antiquities, described it in 1812 as a 'Head of a Homeric Hero' – a very perspicacious title as it turned out, for the head is an evident duplicate of one of the companions of Ulysses in a group representing the blinding of Polyphemus that was discovered in the Cave of Tiberius at Sperlonga in 1957.

Among the other items supplied by Jenkins about this time were a portrait-head of Antinous, also found by Gavin Hamilton; a portrait that Townley described as 'Homer', although now more generally thought to represent Sophocles (fig. 11); a terminal figure (i.e., with a rectangular pillar in place of his body) representing a youth in travelling dress with emblems of Mercury, a *caduceus* (staff) and a cock, carved in relief in the sides of the pillar; a swan made of red marble found not far outside the walls of Rome; a number of alabaster vases including one inscribed with the name Valentina, which was said to have contained coins of the second and early third centuries when found, shown by Chambers on a bracket over the doorway in the hall leading to the staircase (fig. 1); and a large statue of Diana, said to have been found near La Storta, about eight miles from Rome, for which Townley paid £250 (fig. 12). Even more expensive at £350 was a group representing a nymph attempting to escape from the embraces of a satyr (fig. 58, centre foreground), found by Domenico de Angelis not far from Tivoli and subsequently restored by Sposino. From an inventory of the Townley Marbles compiled in 1842 it appears that the sculpture was not then exhibited in the British Museum: this is not an isolated instance of an object that had appealed to the rather prurient taste of the eighteenth century falling foul of nineteenth-century prudery.

In 1773 Townley made his first acquisitions from another old Roman collection, the Mattei: busts of the Roman Emperors Marcus Aurelius (fig. 30, behind the Discus-thrower) and Lucius Verus (fig. 13). Marcus Aurelius is veiled, probably as a member of the Arval Brotherhood, but Lucius Verus is shown in military dress with a cloak (*paludamentum*) over a cuirass. These busts were acquired for £50 and £70 respectively through Gavin Hamilton. Although Townley had previously acquired through other hands sculptures that had been excavated by Hamilton, it was only in 1773 that he began to buy directly from Hamilton himself. Among the other sculptures supplied by Hamilton about this time were a head of Juno for £50; a head wearing a Phrygian cap, probably broken from a statue of Atys, for £45; a head from a statue of a satyr found about four miles from Rome (fig. 14); and a head of Apollo that had passed through several hands. It was bought by Jenkins at the sale of Cardinal Palignae and sold by him to the restorer Cavaceppi for Cardinal Albani, in whose collection it was placed on the trunk of a statue of Bacchus but later exchanged for a head of Bacchus found by Hamilton, who sold it to Townley for £50.

Another acquisition from Hamilton was a small statue of a seated comic actor that eventually found its place in the hall at Park Street, where it was placed on top of a sarcophagus (fig. 1, left). This was discovered in September 1773 in the Villa Fonsega on the Cœlian Hill in Rome. Townley himself was present when it was found, as

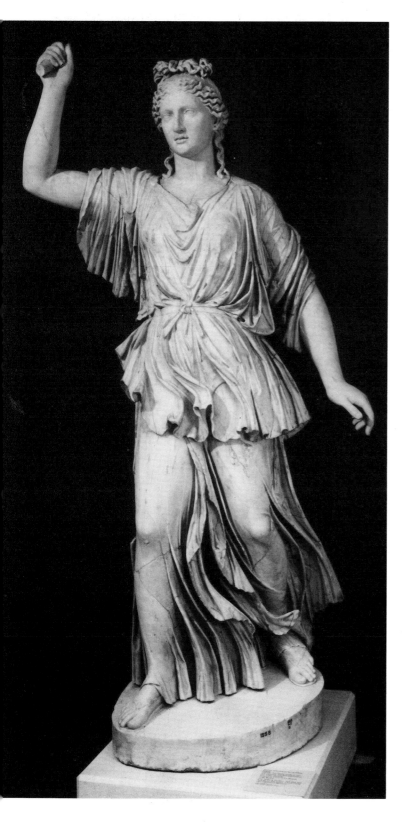

12 Statue of Diana, found *c.* 1772 and acquired through Jenkins, who had it shipped from Leghorn on board the *Success* in 1774. H. 1.84 m. *BM Cat. Sculpture* 1558.

13 Bust of the Emperor Lucius Verus (AD 130–60), formerly in the Mattei collection. H. 93.5 cm. *BM Cat. Sculpture* 1911.

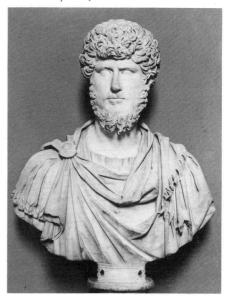

14 Head of a satyr, acquired from Gavin Hamilton for £40. H. 44 cm. *BM Cat. Sculpture* 1661.

he recorded in a manuscript preserved in the Lancashire Record Office. The restoration was done by Giovanni Pierantoni.

Townley also purchased a number of items that Hamilton had obtained at the Adams sale in Rome in 1773, including the circular fountain that he presented to the British Museum in 1786 and a seated figure of Jupiter (fig.1, at the far end of the sarcophagus on the left), which was restored by Albacini and shipped on board the *Rhoda* from Leghorn in 1776. Another interesting object from the Adams sale, acquired by Townley for only £4.10s, was a relief showing Cupids racing in chariots drawn by dogs. It was reputed to come 'from ruins near Frascati', and although Townley described it as a fragment of a frieze it was catalogued in 1904 as part of a sarcophagus. More recently it has been recognised as part of a frieze from the so-called Teatro Maritimo at Hadrian's Villa.

It was also in 1773 that Gavin Hamilton began to dig at a site near Lanuvium known as Monte Cagnolo. Hamilton wrote to Townley that several sites in the neighbourhood had been pointed out to him, but most of them had already been dug: 'Monte Cagnolo alone answered my expectations. This is a small hill betwixt Genzano and Civita Lavinia, commands a fine prospect toward

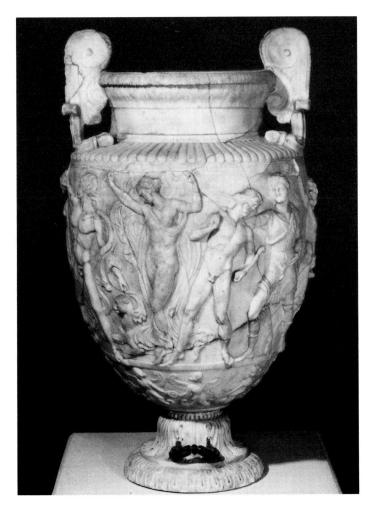

15 The Townley Vase. In writing his *Ode on a Grecian Urn* Keats no doubt had in mind decorative vases of this kind, now known to be of Roman date, but his complex poetic imagery had more than one source, and the claim that this vase served as his chief inspiration cannot be upheld. H. 93.3 cm. *BM Cat. Sculpture* 2500.

Velletri & the sea, and from the magnificence of the ruins & other things found there one must judge it to have been anciently parts of the villa of Antoninus Pius, which he built near the ancient Lavinium, this spot had been reduced in the lower age to a vineyard & consequently strip'd of its' ornaments, some of which I found thrown promiscuously into one room about ten feet under ground.' Among the sculptures found there by Hamilton was a large marble vase decorated in relief with a Bacchic scene including Pan, satyrs and maenads (fig.15). Hamilton wrote that the vase was 'restored with great attention as the work deserves', and Townley paid him £250 for it in 1774. It is known as the Townley Vase.

Another splendid sculpture from Monte Cagnolo is a group showing Actaeon being savaged by his own hounds after he incurred the displeasure of Diana (fig.16). The ancient sources disagree whether this was because he disparaged her skill at hunting or caught sight of her while bathing. The group was one of a pair, both of which were acquired by Townley, although he later exchanged the other with Jenkins for a granite basin. Other sculptures from the same site that also came in pairs were the groups of Victory sacrificing a bull (shown flanking the Townley Vase in

16 Actaeon attacked by his own hounds, acquired from Gavin Hamilton for about £70. H. 1.03 m. *BM Cat. Sculpture* 1568.

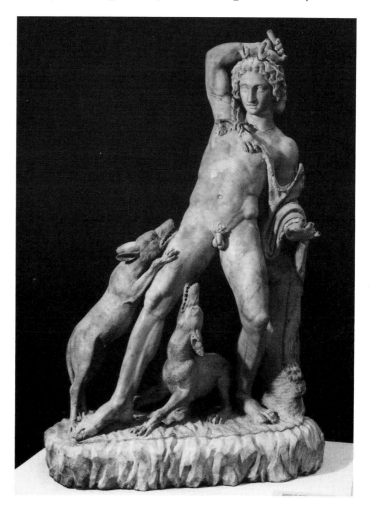

17 Group of two dogs excavated by Gavin Hamilton at 'Monte Cagnolo' ('Dog Hill') together with a companion-piece, now in the Vatican Museum. H. 67 cm. *BM Cat. Sculpture* 2131.

18 Part of a sarcophagus showing the Roman marriage ceremony. Townley exhibited this relief over the door of the dining-room in his Park Street house (faintly visible in fig. 1). H. 98.4 cm. *BM Cat. Sculpture* 2307.

fig.30), statues of a young satyr signed by Marcus Cossutius Cerdo (see p.53), and two groups of dogs (fig.17), of which Hamilton wrote: 'Your group of a Bitch caressing a dog is a masterpiece of its' kind, the companion being a Dog caressing a Bitch is now much admired in the museo Clementino' (i.e., in the Vatican). There were other sculptures of dogs from the site, prompting Hamilton to remark: 'It is somewhat peculiar that so many dogs should be found in a place which still preserves the name of monte Cagnolo.' Other sculptures acquired from Hamilton in 1774 included a small statue of the goddess Fortuna and two inscribed portrait-busts from Roma Vecchia. In the same year Townley bought from the sculptor Carlo Albacini a large fragment of a Roman sarcophagus showing the joining of hands in the Roman marriage ceremony (fig.18).

In 1775 Hamilton turned his attention to Ostia, the ancient port of Rome, where in the ruins of a Roman bath he found a small statue of Venus (fig.19), which was to become one of the principal ornaments of Townley's library. In the same year he also sold to Townley for £100 a bust of Trajan that he had found near Rome (fig.20). It is in remarkably good condition, only the tip of the nose and the upper part of the left ear having been damaged and restored.

Since malaria made Ostia an unhealthy place during June and the autumn, Hamilton employed his men at Roma Vecchia, about five miles south-east of Rome on the road towards Frascati. Here he found a statue of a sleeping youth, sometimes described as Mercury or Adonis but perhaps to be identified as Endymion, which Townley acquired through Jenkins for £300, probably in 1775. This is the date given in the notebook belonging to Simon Towneley, although a later manuscript (quoted in the British Museum

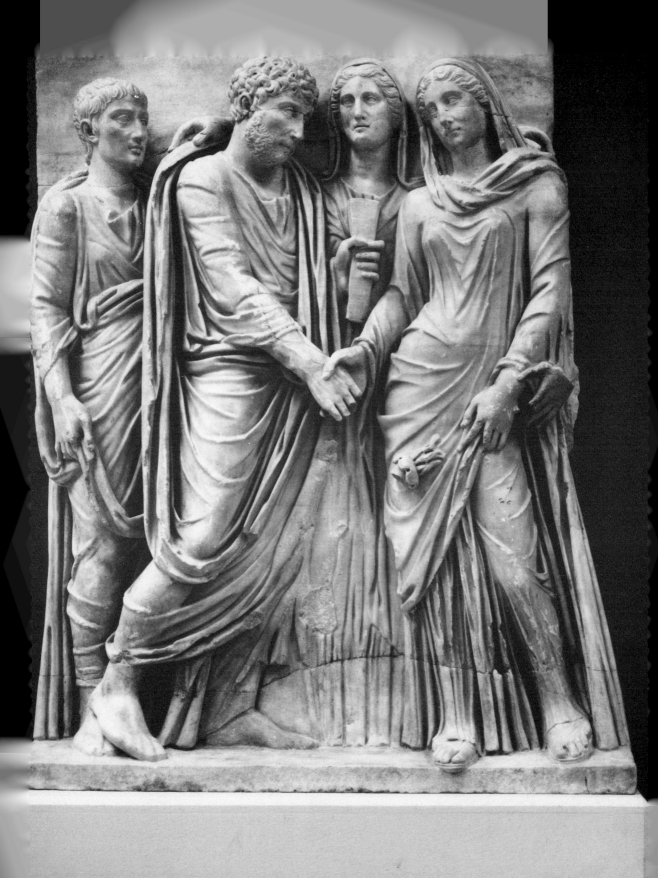

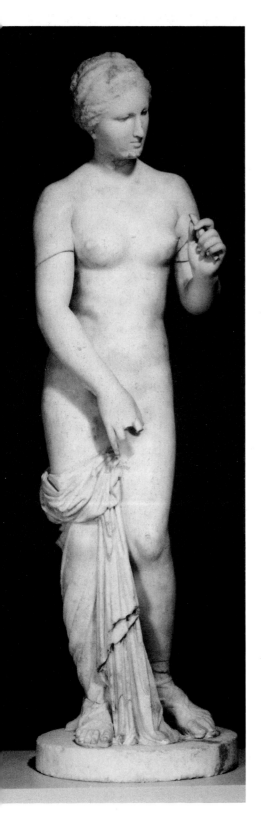

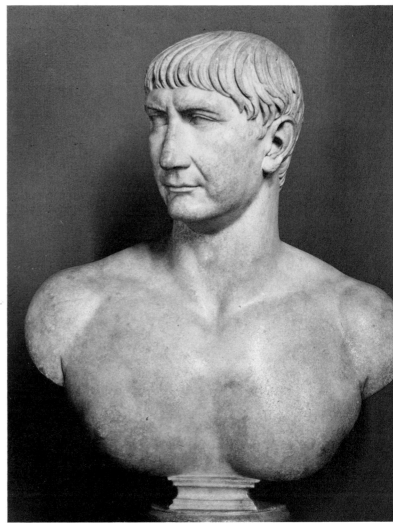

Catalogue) gives the date of discovery as 1776, perhaps by confusion with the date when Jenkins's bill was settled (21 February 1776). Other purchases from Jenkins in 1775 included a relief of a satyr assaulting a nymph (fig.30, high up on the chimney-piece), a sarcophagus-front representing Amazons, previously in the collection of Cardinal Passionei (fig.39, in the niche on the left of the fireplace), and a statue of a fisherman, which Albacini had acquired at the Adams sale.

The following year (1776) was particularly fruitful for Townley. From Hamilton's excavation at Ostia (probably actually conducted in 1775) he acquired for £300 a statue of Thalia, the Muse of Comedy (fig.21), and for £600 another Venus (fig.22), both well over life size. For a splendid relief of two satyrs, a maenad and a panther from Roma Vecchia he paid Hamilton £100. Other purchases from Hamilton included a veiled female terminal figure found not far from Tivoli by Nicolo la Piccola; heads of Jupiter Serapis (fig.23), Athena, Hercules and a Muse; and the large rectan-

19 Statue of Venus excavated at Ostia by Gavin Hamilton and sold to Townley for £100. H. 1.09 m. *BM Cat. Sculpture* 1577.

20 Bust of the Emperor Trajan (AD 53–117), acquired from Gavin Hamilton. H. 76 cm. *BM Cat. Sculpture* 1893.

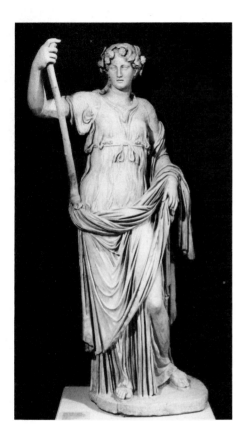

21 Statue of Thalia, the Muse of Comedy, excavated by Gavin Hamilton in the Maritime Baths at Ostia. The bill for packing and shipping was paid by Townley in 1777. H. 1.82 m. *BM Cat. Sculpture* 1685.

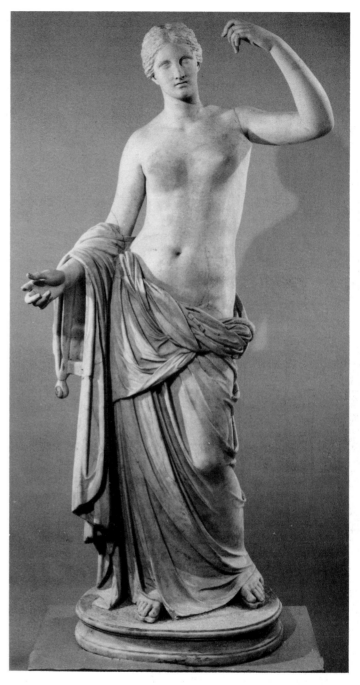

22 'The Townley Venus', excavated at Ostia by Gavin Hamilton. The restorations include the left arm from the shoulder, the right arm from near the elbow, part of the left thigh, some of the drapery and the tip of the nose. H. 2.12 m. *BM Cat. Sculpture* 1574.

gular *cippus*, or grave-marker, of Agria Agatha, which had been known since the sixteenth century.

The large statue of Venus was to become one of the most celebrated sculptures in the collection. Sir Henry Ellis records that in 1814 he heard Canova describe it as 'the finest female statue he

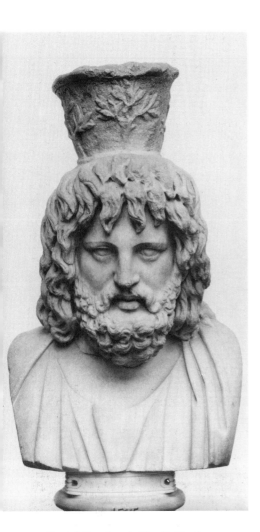

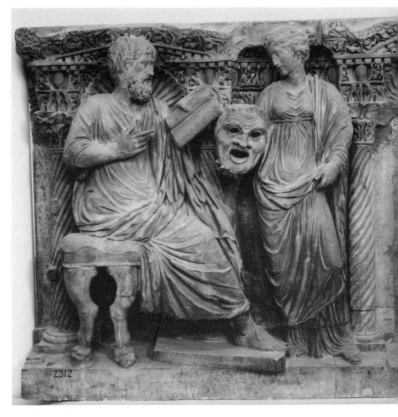

23 Bust of Zeus Serapis, identified by the corn-measure (*modius*) on his head. An attempt to remove the ancient red paint from the vase with acid was made by Francesco Cavaceppi, whom Townley castigated as 'an ignorant sculptor'. H. 58.3 cm. *BM Cat. Sculpture* 1525.

had seen in England'; and in his evidence to the Select Committee of the House of Commons that considered the purchase of the Elgin Marbles in 1816, the architect William Wilkins called it 'one of the finest statues in the world'. It enjoyed no such reputation in Rome, and it has recently been suggested (by F. Haskell and N. Penny) that this disregard resulted from a ruse perpetrated by Hamilton in applying for an export permit. It is not immediately obvious that the statue was made of two separate pieces of marble, since the join is concealed when the naked torso is set into the lower block that forms the drapery. According to the sculptor Nollekens, who was then resident in Rome, in order 'to save the immense duty upon so large and so perfect a figure', the two halves were submitted separately, 'so that the duty upon each fragment amounted to a mere trifle'. Although now known simply as 'The Townley Venus', the statue was long the subject of other interpretations. Called 'Venus' when first found, she was soon identified as Dione, the mother of Venus, since she seemed to lack the *première fleur de jeunesse* that was thought to distinguish statues of Venus herself. Gavin Hamilton wrote of it as the 'mother of Venus' but in later catalogues Townley names it Libera, and even Ariadne.

24 Fragment of a sarcophagus showing a poet and a Muse, found in Rome in 1775 and acquired from Jenkins in the following year. H. 1.06 cm. *BM Cat. Sculpture* 2312.

In the notebook belonging to Simon Towneley the purchase of 'A statue half draped supposed a Dione' is recorded for 1776, although the payment of expenses incurred in Rome and Leghorn was not made until 1777. In a priced list of the collection in the Lancashire Record Office, however, the statue appears as 'Ariadne, Hamilton 1778' only in the addenda, while the list itself includes a marble eagle bought at Sotheby's in 1779. It seems that the statue arrived in London no earlier that 1779.

The record of payments to Jenkins in 1776 is shorter than in earlier years but includes some interesting items: a relief-fragment from a sarcophagus-front showing a Muse standing in front of a seated poet (fig.24), a basalt bath-tub (*labrum*) acquired from the Duke of Bracciano, heir of the Duke of Odescalchi, to whom it had been bequeathed by Queen Christina of Sweden (fig.1, right foreground); and two terminal figures, one of a satyr playing a flute (fig.30, in front of the fireplace) and another of a Hermaphrodite feeding a bird (fig.41, extreme left). The Hermaphrodite cost Townley £20, the satyr and the relief £30 each, but for the *labrum* he paid £200.

In the following year Jenkins supplied a companion-piece to the *labrum*, a granite basin with the same history of ownership (fig.1, in the corresponding place on the other side of the chimney-piece). For this Townley gave him in exchange one of the statues of Actaeon that Gavin Hamilton had excavated at Monte Cagnolo. Townley also bought from him portrait-busts of the Emperors Caracalla and Septimus Severus (fig.41, on brackets in the far bay of the right-hand wall), as well as a head of Hercules, wearing a wreath of poplar secured at the back with ribbons that fall forwards over the shoulders (fig.25).

25 Head of Hercules from near Genzano, acquired through Jenkins in 1777. Many replicas of this head are known, and the original has been attributed to the Greek sculptor Scopas. H. 36 cm. *BM Cat. Sculpture* 1731.

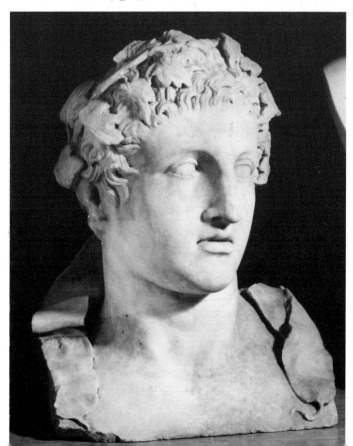

Among the objects Townley acquired from other sources in 1777 were a colossal head of Hercules, excavated by Gavin Hamilton in Hadrian's Villa but bought from Piranesi for £35 (fig.41, left of the doorway). From Francesco Cavaceppi, another sculptor turned restorer, he bought a marble disk (*oscillum*) with reliefs on both sides: such *oscilla* were hung in the courtyards of Roman houses. Battista de Demenicis supplied some inscriptions and a pair of lions' heads in relief from the front of a sarcophagus. Townley had these restored by Albacini and placed them in the niches flanking the chimney-piece in the hall (fig.1). He also acquired for £50 from Count Frederic Giraud a head of a maenad (fig.30, on the bracket at the right side of the chimney-piece).

Townley in Park Street, Westminster

By this time Townley had been back in England for some years (he returned in April 1774) and was well established at the house in Park Street, which he had acquired when his previous house proved unsuitable for the collection. 'This house', wrote John Thomas Smith, 'which was purchased by Mr. Townley in that state denominated by the builders "a shell", was finished according to his own taste.' What this meant in practice may be seen not only in the pictures of the interior of the house (figs 1, 30 and 40), but also in an account of the decoration of the dining-room by d'Hancarville (see p.30), who was often a guest at Townley's famous dinner-parties and had doubtless heard Townley himself explain it. The description is found in a catalogue of the collection in French, copied by Townley from d'Hancarville's manuscript.* A translation, not in Townley's hand, is among the Townley papers in the British Museum:

> The aim in the decoration of this room was principally to recal the eye in particular upon each of the marbles which it contains, and for that end it is attempted to fix the view betwixt the spaces shut in by columns, which being of a dark red colour, prevents the sight from wandering upon too many objects at once. These columns appearing dark upon a blue ground, calculated to bring out the marbles, prevents their being confused with objects adjoining.

> This disposition does not take from the room the character of what it was destined for, the use of the table; all the ornaments are relative to the attributes of those Gods, who were supposed by the antients to preside over the festive board. The Ionic columns in Scagliola, perfectly resembling porphyry, support an entablature, the frieze of which is ornamented with festoons of Ivy, and trophys composed of the instruments used in orgies. The capitals of the columns are taken from an ancient model found at Terracina; the ove is covered with three masks representing the three kinds of ancient drama, the comic, tragic

and satyritic, supported by a bead of pearls; the abacus is ornamented with an Ivy branch; the volutes form a cornucopia, from whence usher forth ears of Corn and Ivy leaves, plants consecrated to Bacchus and Ceres; a flower forms the eye of the volute, which terminates in a Pine cone. The choice and disposition of these ornaments leave no doubt that this capital was intended to characterise a building consecrated to Bacchus and Ceres, whose feasts and Mysteries were celebrated together in the famous Temple of Eleusis.

Within this environment the sculptures were exhibited, in Dallaway's words, 'with an arrangement clasically correct, and with accompaniments so admirably selected, that the interior of a Roman villa might be inspected in our own metropolis'.

Townley's purchases from dealers in Rome were now made at a distance, but he was beginning to make use of another source of acquisitions for his collection – sculptures that appeared on the market in London, which then as now was a centre of the trade in art and antiquities. In 1778 he bought two lots at Christie's from the collection of Henry Constantine Jennings, a relief showing a figure of Priapus in a rustic setting and a statue of a sleeping Cupid. According to one of the Townley manuscripts, the latter had formerly belonged to Cardinal Albani and was brought to England by Lyde Browne, a Governor of the Bank of England who during the previous thirty years had built a large collection in his country house at Wimbledon. In the same year Townley bought several items direct from Lyde Browne. They included heads of a Muse and an Amazon (fig.26); a head of a barbarian, said to have been found in the Forum of Trajan at Rome and therefore formerly identified as Decebalus, the Dacian leader subdued by Trajan; a portrait of a Roman citizen wearing his toga in the third-century fashion with a broad fold across the chest, long believed to represent the Emperor Gordian (fig.41, on a bracket at the extreme right); and an alabaster vase (fig.30, on the mantleshelf).

Lyde Browne also supplied Townley with three marbles brought from Greece by Dr Anthony Askew, which he had himself acquired at the Askew sale in 1775: a portrait-head of Nero, a marble shield inscribed with a list of Ephebes (young men completing their education, fig.41, on the right of the doorway), and the grave-relief of Xanthippos (fig.27). This relief, which can be dated about 430 BC, a decade or so after the completion of the Parthenon sculptures, is the only fifth-century Greek original in the Townley collection. Other sculptures that were believed by Townley and his contemporaries to be Greek originals are now recognised to be of Roman date. In writing to Townley 'Never forget that the most valuable acquisition a man of refined taste can make is a piece of fine Greek sculpture', Gavin Hamilton is clearly referring to the sculptures he had himself supplied, every single one of which, as we know, was Roman rather than Greek.

The notebook belonging to Simon Towneley shows that at this period Townley was settling his account with Jenkins annually, in June or July. The account settled on 10 June 1779 includes only one marble, the cinerary urn of the Titus Titulenus Isauricus, which had been obtained from Albacini for £7. The inscription had been

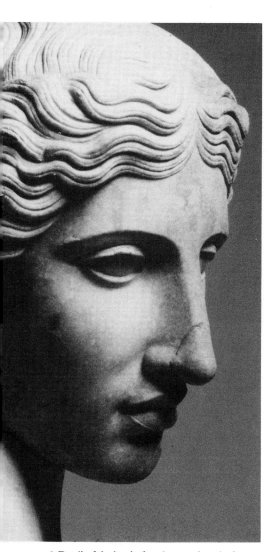

26 Detail of the head of an Amazon bought from Lyde Brown for £50. There are many ancient replicas of the type, including a complete statue acquired by Lord Shelburne about the same time as Townley's purchase and long in Lansdowne House (now in the Metropolitan Museum of Art, New York). *BM Cat. Sculpture* 503.

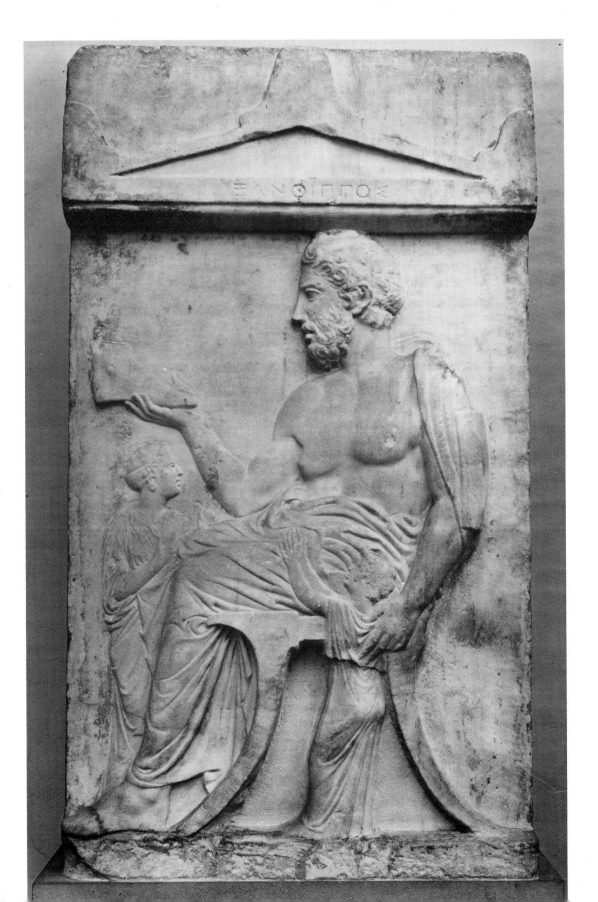

27 Grave relief of Xanthippos, made in Athens *c*. 430 BC. So little was known in the eighteenth century about original Greek sculptures that Townley was able to acquire this splendid example for only £20. H. 83.3 cm. *BM Cat. Sculpture* 628.

28 Statue of a young fisherman, described by Townley as 'a Priapeid votive statue' or 'Paris as Silvanus', as engraved by W. Taylor after a drawing by H. Corbould. *Ancient Marbles in the British Museum* Part x (1845). *BM Cat. Sculpture* 1765.

copied as early as 1662 and the urn was later in the Mattei collection. In the same year, according to a notebook in the Lancashire Record Office, he bought another item from the Burioni collection, not as previously through Pacili but direct from the heirs – a sarcophagus with the portrait of an elderly man in a medallion supported by two flying Cupids.

The same notebook records the purchase of a male head in low relief (fig.41, left of the doorway), which had been acquired about 1770 from a *palazzo* in Florence by a painter called Patch. Years later Townley was to buy the companion-piece, of which he wrote: 'A Portrait similar to this in a medallion of the same size was purchased at Rome by the late Sir William Stanhope, who placed it in his villa at Twickenham, formerly the residence of Mr. Pope. It is now added to this collection, but it is of Roman Sculpture, and much inferior to that of the present Article, which is evidently of Grecian work.' Unfortunately in this fine distinction between Greek and Roman Townley was again mistaken. Both sculptures are in fact modern, presumably carved in the same eighteenth-century workshop.

The notebooks record various purchases at Christie's in 1779. Some are not yet certainly identified, but one of them was the eagle bought at the Beaumont sale that seems to be the latest acquisition given in the priced list of the collection in Preston (see p.25). Another, which came from the second Jennings sale, was a statue of a young fisherman carrying a basket. As Sir Henry Ellis remarked in 1846, 'Mr. Townley, in his own catalogue, called this a Priapeid votive statue.' Ellis was evidently puzzled by this description, but early illustrations of the piece, including an engraving published as late as 1845 (fig.28), presumably from an earlier drawing, make it clear that the fisherman was endowed with a huge penis, the end of which was clearly visible beneath the hem of his short tunic. This feature is no longer present. It seems to have been removed before Ellis wrote his account, another victim of nineteenth-century prudery.

The Townley Venus, which had been hidden among the addenda of the priced list of sculptures in the Lancashire Record Office, appears at the head of another list (also in Preston) which must therefore have been compiled later, perhaps as a replacement after the arrival in London of the statues of Venus and Thalia. This second list includes items bought in 1779 but omits others bought from May 1780 onwards, so it must have been compiled late in 1779 or early in 1780. It therefore provides an indication of the latest possible date of purchase for several sculptures for which such information is otherwise lacking, including a statue of Bacchus as a child (fig.41, placed to the right of Venus) and a statuette of Cupid bending a bow that must have been very celebrated in antiquity, to judge from the number of copies that have survived: Townley himself is reputed to have seen no fewer than thirteen (fig.29).

In May 1780 Townley bought three inscriptions at the Beauclerk sale. Topham Beauclerk is best known for his frequent appearances in the pages of Boswell; indeed, he has been described as 'one of the brightest ornaments of Dr. Johnson's society'. He was not a collector of ancient marbles as such, but among his possessions were some inscriptions that his father, Lord Sydney Beauclerk, a

29 Cupid bending a bow, a Roman version of a Greek statue of the 4th century BC, perhaps the work of Lysippos described by the travel-writer Pausanias. H. 62 cm. *BM Cat. Sculpture* 1673.

30 *Charles Townley's Library* by Johan Zoffany. Exhibited in its first state at the Royal Academy in 1783 and reworked after the acquisition of the Discus-thrower about ten years later. Townley Hall Art Gallery and Museums, Burnley.

notorious fortune-hunter, had inherited from a Mr Topham of Windsor. One was the dedicatory inscription from the tomb of Aktiakos, son of Hermogenes at Smyrna (fig.1, on the wall behind the sphinx); another was the gravestone of a ten-year-old girl named Avita; and the third was a votive inscription for the safety of the Emperor Septimus Severus and his family, of particular interest because the name of Geta was later erased when his brother Caracalla had him condemned posthumously.

Zoffany's painting of the collection

Although no purchases from Italy are recorded for 1780, the following year was more fruitful. It was also in 1781 that Johan Zoffany began his celebrated painting of Townley in his library, surrounded by many of his sculptures in a purely imaginary arrangement (fig.30). The sphinx in the right foreground was a very recent acquisition, as was the terminal bust of Homer shown on a marble column immediately behind Townley's chair. The collection had by now reached a stage when it might be considered 'complete', and it was perhaps to commemorate this fact that Townley commissioned the painting from Zoffany, then at the height of his fame after exhibiting at the Royal Academy in 1780 his painting of the *Tribuna of the Uffizi*.

The collection was never, of course, arranged as Zoffany portrayed it. A few of the sculptures in the painting were normally kept in the library, and some of the smaller items were perhaps carried in from the adjacent drawing-rooms, but reliefs mounted on the walls (fig.31) and heavier figures like the large Venus could not have been brought upstairs from the dining-room and were simply 'painted in'. This procedure also allowed Zoffany licence to alter the relative sizes of the sculptures: the Townley Venus, for example, was reduced in height by one-fifth in relation to the puteal on which Zoffany represented it. The most eccentric introduction was perhaps the inscribed marble shield (see p.27), which is made to serve as a base for the group of the struggling nymph and satyr.

Townley subsequently provided at Zoffany's request a list of the sculptures, which is now preserved, like the painting itself, in Towneley Hall Art Gallery and Museums, Burnley. This list also names Townley's companions. Seated in the centre is 'Mr. d'Hancarville', also known as Baron d'Hancarville, although there is no reason to suppose that the title was not self-conferred. His real name was Pierre François Hugues, and he was an adventurer and known thief, who more than once saw the inside of prison for debt. In more fortunate periods he managed by his wits to live – often at a high standard – at the expense of men like the Duke of Wurtemberg, Sir William Hamilton, the Grand Duke of Tuscany and Charles Townley. On Hamilton's behalf (and at his expense) he published in four sumptuous volumes the collection of vases that Hamilton had acquired as Ambassador of Naples. Expelled from Naples in 1770, apparently for publishing blatant pornography, he

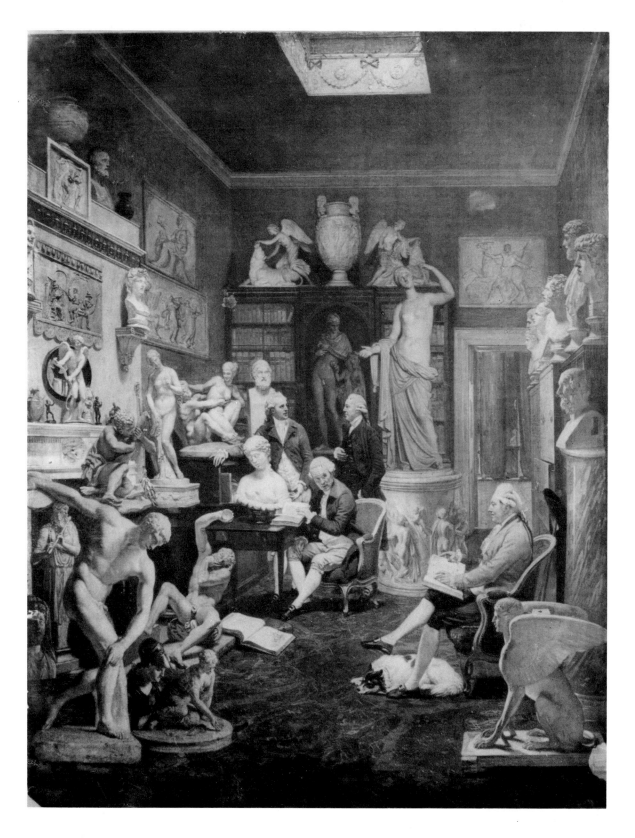

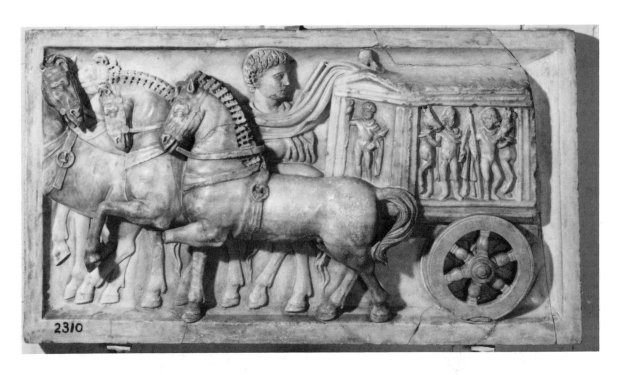

31 Relief of a horse-drawn cart (*tensa*) on which images of Jupiter and the Dioscuri were taken from the Capitol to the Circus for the games. Much restored, especially at the left, by Antonio Minelli, from whom Townley acquired it in 1773 for £16. H. 47.5 cm. *BM Cat. Sculpture* 2310.

lived for some time in Florence and by 1777 had arrived in London, where he again sponged on Sir William Hamilton until taken up by Townley. He began by cataloguing Townley's sculptures and went on to write *Recherches sur l'Origine, L'Esprit et les Progrès des Arts de la Grèce* (1785), an encyclopedic farrago of classical and oriental mythology, in which he tried to explain the iconography of ancient art in symbolic terms, seeing everywhere references to the ancient mystery religions. He had long believed that popular religion was the basis of art: he now saw sexuality expressed in fertility cults as the basis of religion, uniting the creative and the procreative urge. Much of this work, published in 1785, was written in Townley's house.

Standing behind d'Hancarville are the Hon. Charles Greville and Thomas Astle. Greville, nephew of Sir William Hamilton and a former protector of 'Emma Hart', later Lady Hamilton, was the owner of a statue that was eventually to enter Townley's collection (see p.43). Astle was a distinguished palaeographer, who was at this time Chief Clerk to the Record Office at the Tower, where he became Keeper of Records in 1783.

About the same time as he had Zoffany paint the collection, Townley began to produce the manuscript catalogues that record its arrangement. An earlier catalogue, in which the sculptures are listed by category – statues, heads, reliefs, and so on – rather than by location, seems to have been originally compiled about 1781, or not long after the second of the priced lists in Preston (about 1780): there are very few additional objects, and even the order in which they are given is almost identical. This classified catalogue, which is in the library of the British Museum's Department of Greek and Roman Antiquities, was augmented in 1786 by several extra leaves, easily distinguished from the original leaves by their watermarks.

The new leaves contain entries on objects acquired in the intervening years.

The earliest catalogue in which the sequence of entries follows the arrangement room by room is dated 1782 and is now in Preston.* It gives only a summary title to each object but adds both the name of the person from whom it was acquired and the price. The confidential nature of these details suggests that the list was compiled for Townley's own use, unlike the later 'Parlour Catalogues', which were intended for the use of visitors to the house. Comparison of the sequences in which the sculptures are listed in the various catalogues shows that although many objects were moved from room to room as well as being re-arranged within the various rooms, most of the larger statues and the wall-mounted reliefs found their places in the scheme very early. They are recognisably in the same places in all the catalogues from 1782 to 1804. The reason is not far to seek: the larger sculptures could be moved only by employing whole teams of masons, and some were confined by their weight to the ground floor. Similarly, reliefs mounted on the walls could not be moved without skilled labour and the additional inconvenience of damage to the decorations.

The actual arrangement of the sculptures in the library at the time when Zoffany was painting there can be inferred with a good deal of certainty by applying the sequence of the 1782 catalogue to

32 The library in Charles Townley's house in Park Street, Westminster, showing the actual arrangement of sculptures on the chimney-piece and in the niches on the right. Pencil drawing. Department of Greek and Roman Antiquities, British Museum (Townley Drawings).

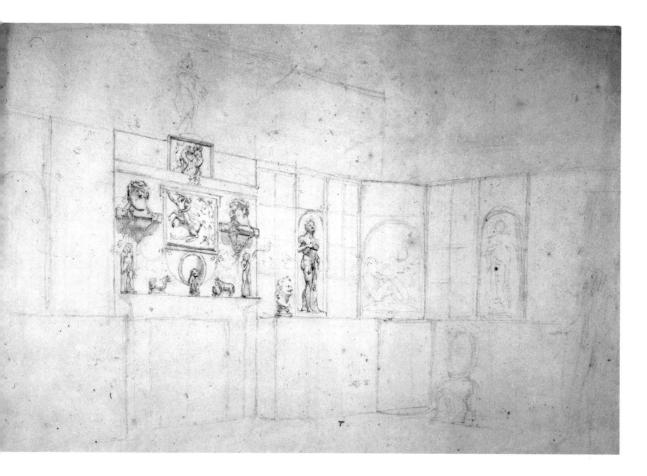

what can be seen of the real appearance of the library in a drawing in the British Museum (fig. 32). From this drawing it is evident that there was a range of bookshelves on the right of the chimney-piece, with niches for sculptures in the corner of the room and half-way between the corner and both the chimney-piece and the door. The latter is seen also in Zoffany's picture, but the painter suppressed the bookshelves beside the chimney-piece in order to find space for reliefs that were actually displayed elsewhere in the house. The assumption that a symmetrical scheme demands a corresponding range of bookshelves with niches on the left of the chimney-piece is borne out by the 1782 catalogue, from which it is evident that the corner niche on the right was occupied by the group of a satyr struggling with a nymph, while the corresponding niche on the left held the Knucklebone-players. The drawing shows that the satyr restored by Algardi stood in the niche towards the chimney-piece on the right, and this agrees with the sequence in the 1782 catalogue, which adds that the small Venus from Ostia stood in the niche on the left, outside the scope of the drawing. Zoffany painted the Knucklebone-players, the small Venus and the satyr and nymph outside their niches but maintained the actual sequence from left to right.

Between the niches, smaller sculptures – heads and statuettes – stood on the projecting ledge formed by the deeper cupboards beneath the bookcases. Immediately flanking the chimney-piece in 1782 were the heads of a satyr and a maenad that Zoffany portrayed on the two brackets normally occupied by terracotta heads of Bacchus. Their rather precarious appearance suggests that they were actually placed on the brackets for Zoffany to paint, unlike many of the larger sculptures, which were merely introduced into the composition, often with some distortion of scale to make them appear to fit.

Zoffany's treatment of the rest of the chimney-piece is a blend of fact and imagination. The drawing and the manuscripts agree that immediately above the mirror was a marble relief of Nessos and Deianeira (see p. 51), which Zoffany replaced with a terracotta relief of the construction of the Argo. The upper relief, which shows a satyr assaulting a nymph, was actually in the place where Zoffany portrayed it, a distinction that it shares only with the alabaster vase and the small head on the mantleshelf. The Cupid that Zoffany showed between them was actually one of the ornaments of the drawing-room (fig. 29). Another imaginative touch is the apparent incorporation into the fireplace of a relief showing two theatrical masks, the acquisition of which is otherwise undocumented.

Turning the corner from the group of the satyr and nymph, a similar scheme with a niche set into bookcases may be observed. Here at least Zoffany's painting seems to preserve the actual appearance of the furniture, although he introduces into the niche the statue of Bacchus and the vine that was actually displayed in the dining-room (fig. 41, right foreground) and poises above it the marble vase and the Victories sacrificing bulls that were excavated at Monte Cagnolo. In fact any one of these would have been heavy enough to crush a wooden bookcase to splinters. The doorway on the right of the bookcase is actually correctly shown: Zoffany could

hardly tamper with major architectural features like the doorway and the skylight, which provided such excellent top lighting for the library.

The appearance of the wall opposite the fireplace may be reconstructed from the evidence supplied by Zoffany and the 1782 catalogue. From the catalogue it is evident that two groups of three heads flanked the marble sphinx, which was therefore probably opposite the fireplace, not far from where Zoffany placed it. Near the doorway he shows a high wooden press with sculptures on top. It seems unlikely that he could have invented this: it is one thing to suppress a bookcase in order to cover the wall with reliefs, it is quite another to introduce a large and bulky piece of furniture where none existed. Symmetry again demands that a second press stood towards the right, out of the field of view of the painting. These two presses, like the bases of the bookcases on the other walls, were no doubt suitably reinforced to take the weight of the sculptures that Townley placed on them. Zoffany crowds six heads on top of the press near the doorway, where Townley actually had only three. Four of Zoffany's six were displayed elsewhere according to the 1782 catalogue, but the tall bust of Lucius Verus (fig.13)

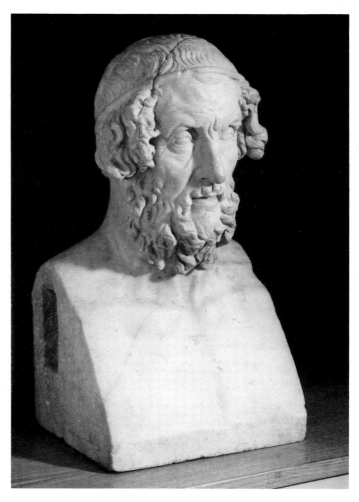

33 Portrait of Homer found at Baiae near Naples *c.* 1780 and purchased by Townley from Gavin Hamilton for £80. *BM Cat. Sculpture* 1825.

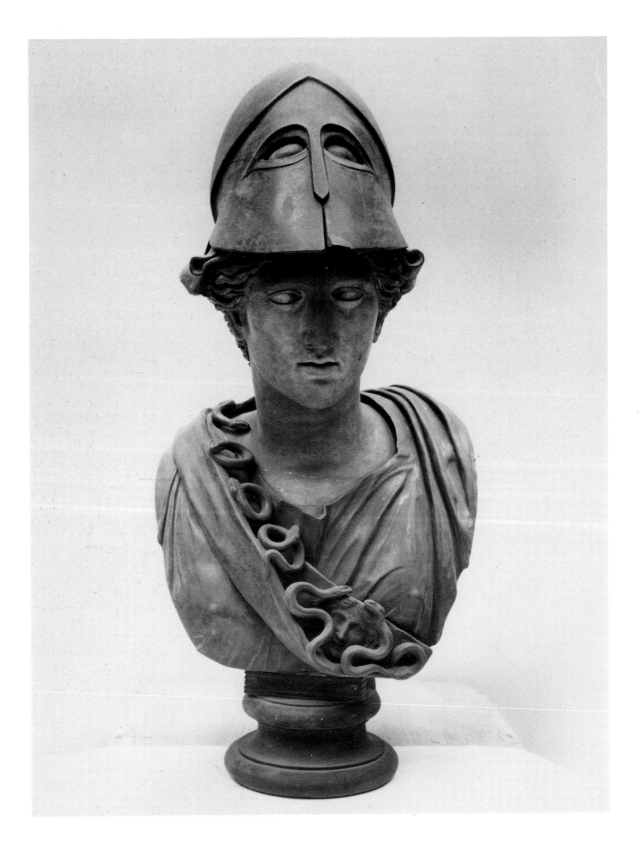

34 Bust of Minerva. The marble head was found on the Esquiline Hill in Rome, and the bronze bust and helmet were made for it by the sculptor Carlo Albacini. H., as restored, 81.5 cm. *BM Cat. Sculpture* 1571.

and the head of the Homeric hero (fig.10) beyond it were both normally on the other press, just out of the picture on the right.

Like the sphinx, the bust of Homer (fig.33) on the column behind Townley's chair was a fairly recent acquisition when the picture was painted. This column supported various sculptures at different periods. Around 1782 it probably held a terracotta statue (not included among the marbles in the 1782 catalogue), which was later moved to the niche near the doorway. It may well have been moved at the time of the painting to provide a temporary lodging on the column for the more important bust of Homer.

Later acquisitions, 1782-1786

In addition to providing information on the arrangement of the sculptures, the 1782 catalogue serves as a terminus for the arrival in the collection of various objects of which the acquisition is otherwise undated. These include a small torso of Venus bought from Cavaceppi, two small terminal busts of Bacchus in the yellow marble known as *giallo antico*, and a console with a figure of Victory in front of the volute, which Townley acquired from Piranesi for £25. Not listed in the 1782 catalogue but seen in the left foreground of the Zoffany is a bust of Minerva (fig.34) acquired through Jenkins for £100.

Zoffany's painting was completed (at least in its first state – the Discus-thrower was to be added a decade or so later) in 1783. From this time on Townley was to make relatively few new acquisitions. Various dates are given in the manuscript sources for the discovery near Tivoli by Gavin Hamilton of a terminal portrait-bust of the Athenian statesman Pericles, but a bill for shipping it was settled on 20 April 1784. A relief of Priam begging for the return of the body of his son Hector from Achilles, which had been brought from Rome by Mr Morrison, was obtained from him together with another relief in exchange for a bust said to be of Albinus that Townley had brought at the Rumbold sale in June 1784.

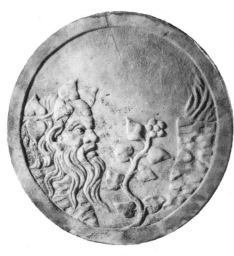

35 Marble disk (*oscillum*) with a satyr's head, an ivy branch and an altar. Such disks were suspended between the columns of peristyle gardens in Roman houses. Diam. 26 cm. *BM Cat. Sculpture* 2456.

Among the entries for April 1785 in Simon Towneley's notebook (which ends in December of that year) are the expenses for shipping a relief of Hercules struggling with the deer and a small terminal head of Bacchus in the red marble known as *rosso antico*, which were 'sent from Rome by Mr. Byres'. James Byres (1734-1817) was an architectural draughtsman who had left Scotland as a boy with his father after the failure of the Jacobite rebellion in 1745. He settled in Rome and eventually became an 'antiquarian' or tourist guide for English visitors, including Gibbon in 1764 and Boswell in 1765. He also traded in antiquities, the most celebrated of which was the Portland Vase, which he bought from the Dowager Princess Barberini and sold to Sir William Hamilton. Another object sent by Byres was a marble disk, or *oscillum*, with the head of a satyr, an ivy branch and an altar in very low relief (fig.35). Like the other objects sent by Byres it is listed in Townley's first classified catalogue, not among the original entries but on leaves with a different watermark.

Other entries on these leaves include objects bought at auction

in June 1785 (funerary inscriptions from the collection of Matthew Duane) and July 1786 (two cinerary urns from Sir Charles Frederick's collection), but neither the alabaster vases from the Duchess of Portland's sale in June 1786 nor any other object for which a later purchase date is known. This catalogue seems, then, to have reached its definitive state in the latter part of 1786.

Another sculpture acquired in 1786, perhaps the last to be added to the classified catalogue, was a statue of a Caryatid over 2m high (fig. 36). It had been found near the Via Appia outside Rome during the pontificate of Pope Sixtus v (1585-90), and with a companion-piece now in the Vatican had in the meantime been in the Villa Montalto, from which Jenkins obtained it for Townley. It was a celebrated piece, having been engraved by Piranesi and discussed by Winckelmann. Piranesi's engraving shows the Caryatid and other statues incorporated in the portico of a small temple, 'restored', as Townley wrote, 'to the state in which, as he imagines, it originally stood. His composition is ingenious but I was informed by professional and intelligent persons at Rome that no facts or circumstances ever existed relative to these statues to verify his conjecture'.

The arrival of the statue in Park Street was the occasion of a

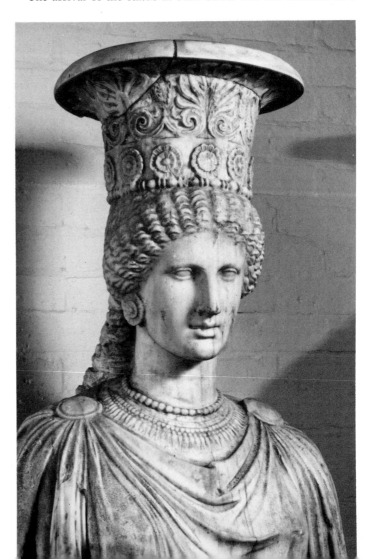

36 Upper part of a figure of a Caryatid, previously in the Villa Montalto, acquired through Jenkins for £400. Total H. 2.37 m. *BM Cat. Sculpture* 1746.

rearrangement of sculpture in the dining-room. From the 1782 catalogue it is evident that at that time the large statue of Venus from Ostia stood opposite the fireplace, no doubt in the central position demanded by symmetry, beneath the relief mounted centrally high on the wall. In order to accommodate the Caryatid, the Venus was moved off-centre to the right and the Caryatid was placed in a corresponding position on the left. Since neither piece would now obstruct the view of the relief, it was probably at the same time that the opportunity was taken to place them on pedestals somewhat taller than the one on which the Venus previously stood. Indeed, it would have been desirable to mount the Caryatid on a fairly tall base since her right hand projects forward at waist level and must be raised above the heads of visitors. The final arrangement of the Park Street dining-room can be seen in fig.41. The reliefs that decorate the fronts of the two pedestals are the ends of a marble sarcophagus that were sawn off so that they and the front (fig.37) could be exhibited on the staircase of the Villa Montalto. Townley also acquired the front, which he had mounted on the wall in the hall (fig.1 left), and the three pieces were later reunited in the British Museum.

Another purchase from the Villa Montalto that led to a re-

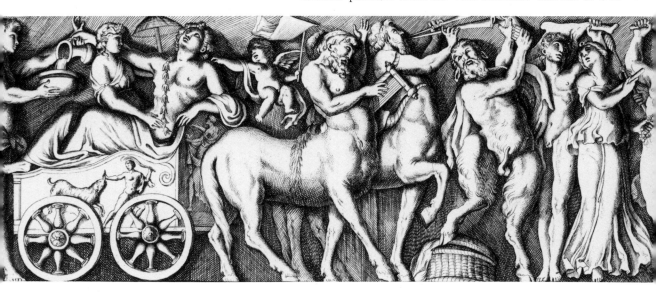

37 Part of the front of a Roman marble sarcophagus showing Bacchus and Ariadne in a cart drawn by centaurs, as engraved by Bartoli in 1693. The sarcophagus was acquired by Townley *c.* 1786. *BM Cat. Sculpture* 2298.

arrangement, this time in the hall at Park Street, was a relief of Bacchus and his entourage visiting the house of a mortal, often thought to represent Icarius, whom the god taught how to cultivate the vine (fig.38). Townley mounted it in the elaborate chimney-piece of the hall, where it displaced the relief of the Poet and Muse to a position facing the doorway (fig.1; compare the earlier arrangement in fig.39). In a niche beneath the Poet and Muse, partially obscured in fig.1 by the seated sphinx, Townley placed a relief with three registers that was also acquired from the Villa Montalto, presumably at about the same time. Other marbles acquired from the Villa Montalto included two inscribed *cippi*, one known since the seventeenth century, the other since the late sixteenth, and a portrait-head tentatively identified as Periander.

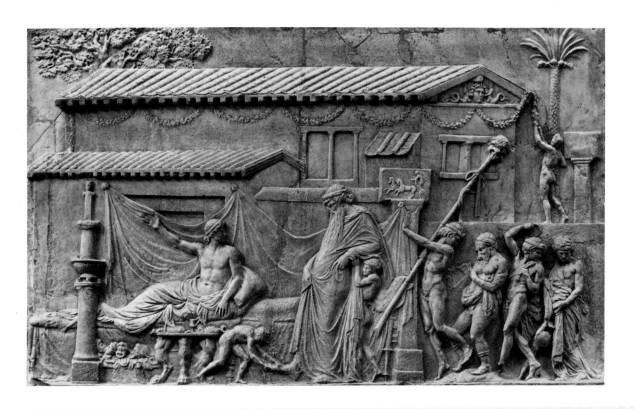

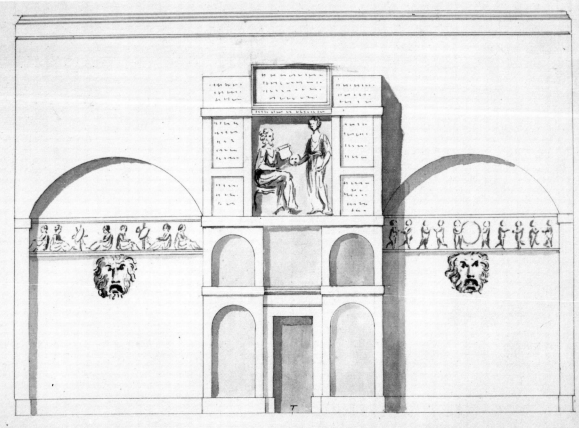

38 Relief showing Bacchus visiting the house of a mortal, perhaps Icarius. The relief was known in the 16th century and was published in 1693 by Bartoli. H. 96 cm. *BM Cat. Sculpture* 2190.

39 Drawing of one wall of the hall in Charles Townley's house showing the chimney-piece, which included niches for urns and incorporated a series of inscribed marble tablets. This is perhaps the 'Chimney piece composed of antient fragments' acquired by Townley from Piranesi in 1768. Department of Greek and Roman Antiquities, British Museum (Townley Drawings).

The Caryatid appears with other items from the Villa Montalto at the end of the list of purchases from Jenkins given by Townley in the notebook now in Preston, but a difference in the ink for these entries suggests that they were added after the initial compilation of the notebook, which seems from other entries to have been completed about 1783. Including the Caryatid, the total paid to Jenkins since 1768 was £4,629. Since in this context £1 means a gold sovereign, the total would be well over a quarter of a million pounds at today's values.

Of the purchases from the Villa Montalto, only the Caryatid is included in the classified catalogue. It is added to the list of statues between numbers 9 and 10, in part on the reverse of the leaf for number 10 and in part on leaves with a different watermark that were evidently tipped in later. Since no sculptures known to have been purchased after 1786 are included in the catalogue, it may again be assumed that objects described in it without a specific date of purchase had in fact been acquired by that year. Such objects include the front of a sarcophagus showing Achilles concealed among the daughters of King Lycomedes (fig.1, upper right), a marble shield with a funerary inscription in Greek, and a shallow marble bowl with a maenad in low relief.

Townley as Curator

By this time Townley had begun to build up a collection of drawings of his sculptures, and at some point in the late 1780s he drew up a 'List of Drawings from Marbles' on a sheet of foolscap now in the British Museum's Department of Greek and Roman Antiquities. It seems to postdate the classified catalogue since it includes two extra marbles, a cinerary urn presented to Townley by Lyde Browne, and a statue of one of the companions of Bacchus, a female figure with a panther at her side. The latter had been found by Gavin Hamilton at Roma Vecchia a decade or so earlier and had been sold by him to the Hon. Charles Greville, from whom it was acquired by Townley. Greville was a member of Townley's circle and was portrayed with him by Zoffany, standing behind the bust of Clytie (fig.9).

The 'List of Drawings' is particularly interesting because, like the 1782 catalogue, it reflects the arrangement of the sculptures in the various rooms. It is, for example, clear that the niche in the library in which Zoffany showed the statue of Bacchus and the Vine was occupied in the late 1780s by the statue of Hecate acquired in 1768, which had been in the dining-room in 1782 and was later to spend brief periods in the drawing-room and the parlour before finding a place in the hall (fig.1, left). The seated sphinx that Townley had at first kept in the library had by now found a place on top of the well-head (puteal) in front of the dining-room windows.

In 1786 Townley was elected a Fellow of the Society of Antiquaries of London, and in 1791 he was appointed to the Board of Trustees of the British Museum, a position he held until his death. As a member of the Standing Committee he took an active part in the formulation of Trustee policy. He had probably already

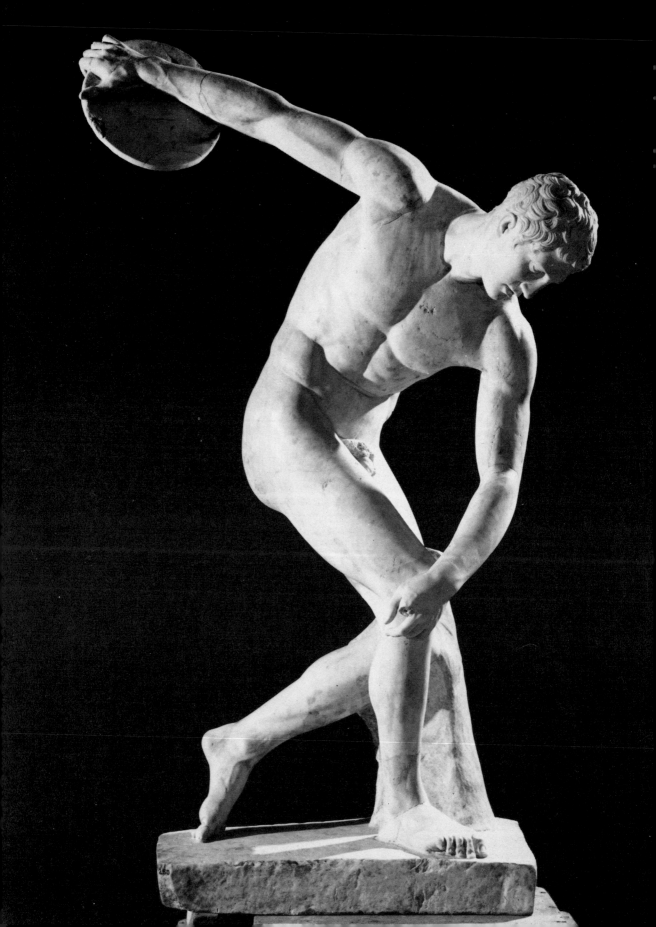

40 The Discus-thrower, a marble copy of a bronze original by Myron, an Athenian sculptor of the 5th century BC. This replica, one of many, was probably commissioned for Hadrian's Villa, where it was found. The head does not belong. H. 1.72 m. *BM Cat. Sculpture* 250.

embarked on the compilation of a new series of catalogues of the collection, of which the earliest seems to be one preserved among the Towneley papers in the Lancashire Record Office:

> A Catalogue of the Ancient Marbles contained in each room of Mr Townley's house in Park Street, Westminster, with an account of the places, in which they were found, or formerly stood.

It might be convenient to refer to this as the L Catalogue, since a paper sticker on the front cover is marked with the letter L (the significance of which is unexplained). Another sticker describes the volume as 'Rough-draft descriptions of articles in Marble of my collection', with a later comment in a different ink 'and some miscellanies'. The 'miscellanies' include a bronze statue of Apollo that Townley had acquired from the Choiseul sale in Paris in 1774 and a bronze Hercules from Syria, which seems from its position in the list of sculptures in the library to have been placed on the marble pedestal opposite the fireplace (see p.36 and fig.30).

The L Catalogue is not dated, but it is evident from the contents that it must have been compiled within two or three years of 1790, certainly after some of the sculptures bought in 1786 had already been mounted and before the arrival of Townley's last important acquisition, the Discus-thrower (fig.40). This statue was found in Hadrian's Villa in 1791 and was the subject of letters from Jenkins in January and March of 1792. Townley paid £400 for it in that year, but it may not have reached England until 1793.* In the L Catalogue, then, we see the collection as it was arranged just before the arrival of the Discus-thrower. In the dining-room the puteal is still in the central position opposite the doorway that it had occupied in 1782, but it now serves as a pedestal for the sphinx that was then upstairs in the library.

In the left bay of the wall opposite the fireplace is the statue of Libera that Townley acquired from Greville, replacing a terminal figure with a head of Jupiter. The latter had been bought from Lyde Browne for £190 in 1778 but seems to have disappeared from all records of the collection compiled after 1782. Its present location is not known. The statue of Hecate (fig.6) has begun its migrations with an initial move from the library to the drawing-room. The comic actor and the seated Muse have been moved from the parlour to the hall: the actor is already on top of the sarcophagus, where he was to remain (fig.1, left), but the Muse has found only a temporary home on the *cippus* of Agria Agatha opposite the front door. The terminal head from Genzano (fig.25) has been moved from the drawing-room to the library (it will soon find a place in the dining-room).

As well as moving sculptures from room to room, Townley had made a number of changes in the arrangement of sculptures within the rooms. This is particularly striking in the wall opposite the fireplace in the dining-room, where only the three wall-mounted reliefs and one of the portraits on brackets still occupy the same places as in 1782. The symmetrical scheme remains, but new acquisitions have necessitated a complete rearrangement.

An arrangement of the collection almost identical with that seen in the L Catalogue is to be found in a catalogue preserved in the

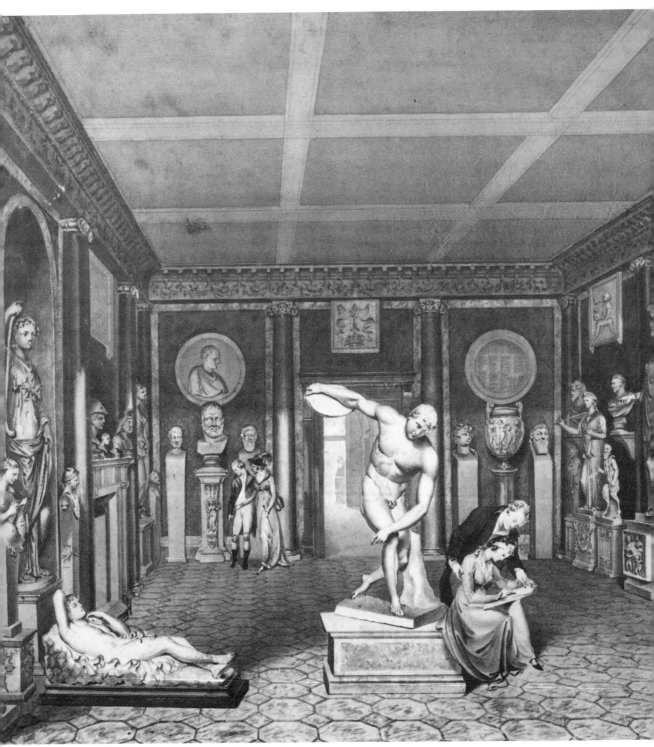

41 The dining-room in Charles Townley's house in Park Street, Westminster.
The three statues in the foreground were actually placed nearer to the wall facing the door;
the remaining statues and reliefs occupy their proper places in the symmetrical
scheme. Watercolour by W. Chambers, *c.* 1793. Collection of Lord O'Hagan.

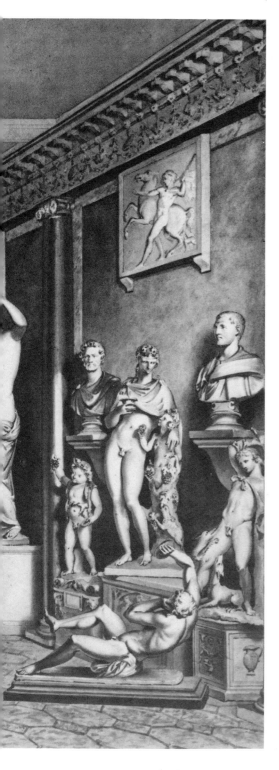

Department of Manuscripts of the British Library (Add.Ms. 34,009), which has the bookplate of Charles Townley's uncle and eventual successor to the estate, John Towneley (who spelled the family name with the additional 'e' that became standard for his descendants). Curiously, some of the leaves of this catalogue are watermarked 1804. As we shall see, the arrangement of the collection had changed quite radically by that time. It seems likely that John Towneley's Catalogue was a fair copy prepared around the time of his nephew's death from an obsolete manuscript, which was close in date to the L Catalogue itself. A significant difference is the inclusion among the sculptures in the dining-room of the Discus-thrower, which is simply added at the end of the list, without regard to its actual position.

Not counting the Discus-thrower, only four objects make their first appearance in John Towneley's Catalogue and the L Catalogue. They include two decorative reliefs, one convex and one concave, which may have come originally from the same cylindrical building. They were acquired from Cavaceppi, who had published them in his *Raccolta*, but the convex relief, which is partially decorated with foliage and birds, had already been engraved by Bellori in 1688.

The Discus-thrower itself was Townley's last major purchase, and its arrival prompted the movement of several sculptures and consequent rearrangements in various rooms. Even Zoffany's painting had to be altered: the statue was added in the left foreground (fig.30). The importance Townley attached to the statue was reflected in its location: a central position at the end of the dining-room, opposite the doorway. This place, as we saw earlier, had long been occupied by the puteal, which served also as a pedestal for the sphinx. Both were now moved to a correspondingly central position opposite the front door, from which they displaced the seated Muse to the parlour and the *cippus* of Agria Agatha, on which the Muse had been placed, to the foot of the staircase outside the dining-room.

The new arrangement is seen in the watercolour by Chambers (fig.1), which together with the corresponding view of the dining-room (fig.41) was painted about this time, perhaps even to celebrate the arrival and placement of the Discus-thrower.* The statue indeed appears in both paintings, being centrally placed at the far end of the dining-room, where it was in the line of sight from the hall. Chambers seems to have exercised some degree of artistic licence in each case: quite apart from the apparent total lack of furniture in the dining-room, the Discus-thrower and the reclining figures on either side of it were probably in reality placed much closer to the windows.

Chambers's painting of the dining-room documents the acquisition of a statue of Pan with goat's legs, presented to Townley by Lord Cawdor, who had brought it from Rome (fig.41, left of the Caryatid). It also appears in one of two pencil sketches (fig.42) of the dining-room made a year or two after Chambers's watercolour, but is not mentioned in any of the earlier catalogues: it seems therefore to have been received between about 1790 and 1793. In the dining-room it displaced a small statue of the goddess Fortuna, which found a temporary home in the library. The two sketches of

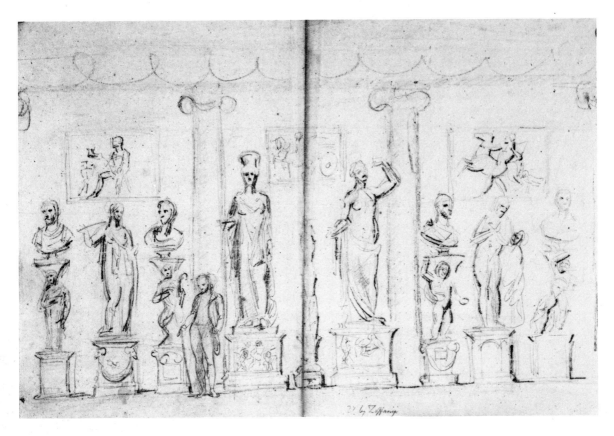

42 Part of the dining-room in Charles Townley's house in Park Street, Westminster. Pencil drawing, *c.* 1794–5: the tentative attribution to Zoffany is almost certainly incorrect. Department of Greek and Roman Antiquities, British Museum (Townley Drawings).

the dining-room are on a single sheet among the Townley drawings in the British Museum's Department of Greek and Roman Antiquities. They were once attributed to Zoffany, presumably as preparatory sketches for a further painting, but the attribution seems unlikely, if only because they show the actual rather than an imaginary arrangement of the sculptures.

Other changes in the arrangement may have been stimulated by the failure of Townley's attempt to obtain larger premises for his collection. On 16 February 1792 he wrote as follows to the Duke of Portland:

My Lord Duke

I have for a long time had a desire to place a collection of ancient marbles, of which I am possessed, in a more spacious and a more secure situation, than my present house in park Street – Mr Stephenson's house in Soho Square is now offered to me, and the ground it occupies affords me space sufficient for my purpose; But as I must make considerable additional buildings on the premises, a permanent tenure in them is necessary to justify me in the expence of such an undertaking. Altho I have not the honor to be personally known to your grace, I am persuaded that you will excuse the liberty I take in requesting the favour to be informed whether, in case I purchase Mr. Stephenson's lease, you will please grant to me a perpetuity of the premises, either by sale of the fee, or by an extension of the present lease, of which there are, I believe, forty four years unexpired.

This draft of his letter is preserved among the Townley papers in the Department of Greek and Roman Antiquities, together with the Duke's reply: he was unwilling to extend the lease and would offer no more than an assurance that he would give his immediate tenant first refusal should he ever decide to sell. Townley never found a larger house and spent the rest of his life in Park Street.

A number of changes in the arrangement of the collection are evident in the next catalogue, which now belongs to Mr Simon Towneley. Most of the leaves have the watermark 1794, which gives the earliest date for the start of compilation of the catalogue. It was not finished until at least 1795, since it includes a bust of Hadrian, formerly in the Villa Montalto, which appears among the addenda to the earlier of the priced lists in Preston as having been bought from Brown [*sic*] in 1795 for £126.

Among the sculptures that appear for the first time in Simon Towneley's Catalogue are a head of Bacchus found in Hadrian's Villa in 1793 (the date 1790 given in the British Museum *Catalogue of Sculpture* is derived from a later manuscript); an altar dedicated to Diana, 'brought from Rome to England by the first Lord Holland 1760'; a head described by Townley as 'Isis in basaltes'

43 Portrait of an Egyptian king of the 'late' period, i.e. after 600 BC, perhaps Amasis or Nectanebo I. H. 38 cm. Department of Egyptian Antiquities, EA 97.

(fig.43); and a marble 'bath chair' (fig.44) which was brought to England by Lyde Browne. This was long thought to be a kind of steam-bath. Townley himself wrote: 'In the centre of the seat is a hollow space in the form of an extended horseshoe thro' which the steam was received.' Sir Henry Ellis supported this interpretation with a learned reference to the *Variae* of Cassiodorus, adding that the chair could also serve 'for water to be poured over the person sitting in it'. These views of the function of this *sella balnearis* were repeated in various British Museum publications as recently as the *Catalogue of Sculpture*, which appeared in 1904. The object is, of course, simply a rather ornate latrine.

The last forty leaves of Simon Towneley's Catalogue are blank, and there is a pencilled note on the last page, dated March 1804 and apparently in Townley's hand, that thirty leaves must be added. These seventy leaves were presumably intended for the sculptures in the dining-room, which is missing from the catalogue as it stands. The missing section may be represented, at least in draft form, by a set of notes on the sculptures in the dining-room preserved among the Towneley papers in the Lancashire Record Office in a folder marked 'Rough catalogue of my marbles'. The sequence

44 Ornate latrine from the 'Antonine Baths', i.e. the Baths of Caracalla. H. 75.5 cm. *BM Cat. Sculpture* 2517.

of the entries certainly represents an arrangement of the sculptures in the dining-room that comes after that shown in the sketch attributed to Zoffany and before that implied in later catalogues.

The Towneley papers in Preston also include a series of 'Notes on Marbles in Park Street', in which the sequence again corresponds to that in Simon Towneley's Catalogue. In these two sources we meet for the first time a group of an African acrobat performing with a crocodile (fig.45), 'brought from Rome by Mr Campbell of Stackpole, who gave it to the present possessor'. Since Mr Campbell was created first Baron Cawdor in 1796, the two manuscripts were presumably complete no later than that year. Later catalogues refer to him correctly as Lord Cawdor.

Another gift from Lord Cawdor, which is recorded only in a later catalogue, was an 'urn' with a snake around the rim (fig.46). Taylor Combe, who became the British Museum's first Keeper of Antiquities in 1808, has left a note in an interleaved copy of the first edition of *Synopsis of the Contents of the British Museum*, published in the same year:

This article is not worthy of the collection in which it is placed.

45 An African acrobat with a crocodile. Restorations include the crocodile's head and parts of the African's limbs. H. 76 cm. *BM Cat. Sculpture* 1768.

46 Marble 'urn' with a snake on the rim, manufactured from a capital by Piranesi and bought from him by Lord Cawdor, who gave it to Townley. H. 57.5 cm. *BM Cat. Sculpture* 2409.

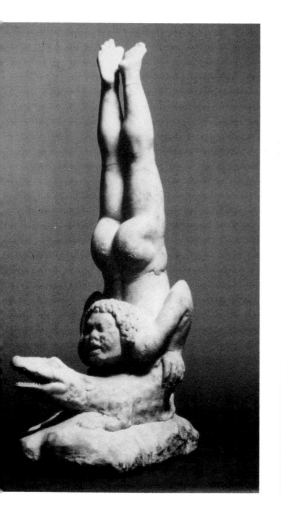

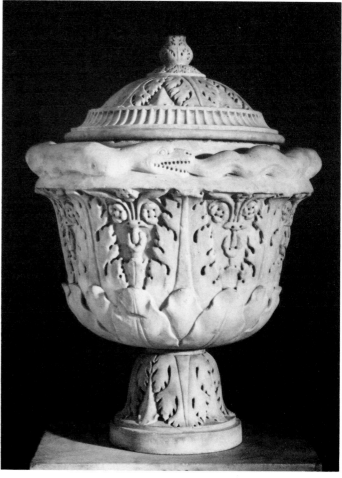

It was originally the capital of an ancient column, but it owes its present form and appearance to the taste and skill of Piranesi. It was sold as an antique urn by the manufacturer to Lord Cawdor, from whose hands it passed into those of Mr. Townley. I had this anecdote from Mr. Gresham, who actually saw Piranesi engaged in the fabrication of this forgery.

'Forgery' is perhaps not too strong a word to apply to Piranesi's procedure on this occasion, which may have had a precedent in the urn with battle-scenes that Townley acquired through Jenkins from Belisario Amidei in 1768 (see p.12): Piranesi certainly made an engraving of the object, and may even have been responsible for the figured decoration. He regularly turned his hand both to the restoration of sculptures found in a damaged or fragmentary state and to the manufacture from smaller fragments of what were virtually new compositions.

Another Roman sculptor who made a fortune restoring and

47 Relief of a centaur abducting a woman, restored by Bartolomeo Cavaceppi and acquired through Jenkins for £40 in 1768. H. 56.5 cm.
BM Cat. Sculpture 2201.

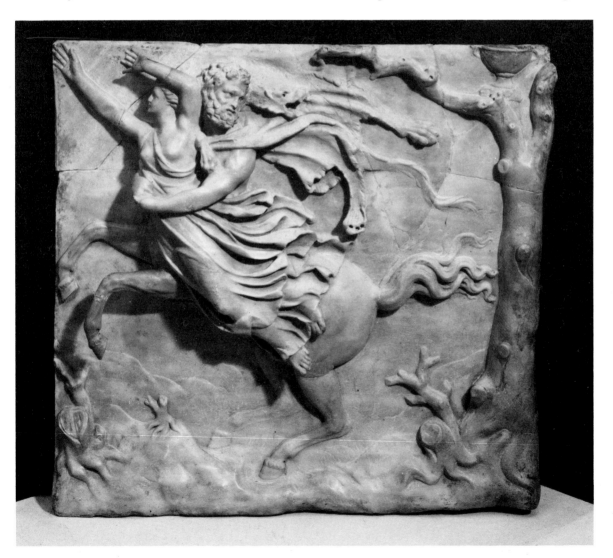

selling ancient marbles was Bartolomeo Cavaceppi. Several of the sculptures in Townley's collection are known to have been restored by him, including a relief of a centaur abducting a woman, usually identified as Nessos and Deianeira, which was also among the objects Townley acquired through Jenkins in 1768 (fig.47). The relief was mounted on a slate back. This was recently removed to reveal part of the text of a Latin funerary inscription on the original face of the slab that Cavaceppi had used to restore the background of the sculpture.

It was, of course, taken for granted in the eighteenth century that fragmentary sculptures should be restored. Cavaceppi claimed with a certain pride that his own restorations were historically accurate, but this cannot be said of everything in Townley's collection. Of the satyr from the Maccarani Palace restored by Algardi Sir Henry Ellis wrote that Townley allowed the restorations to remain out of deference to Algardi's reputation, 'though well aware of the fact that they were inconsistent with the original design of the figure'.

48 Drawing of a marble group of a satyr struggling with a nymph in the collection of Townley's friend Henry Blundell of Ince (now in the Merseyside County Museums). Townley possessed a satyr from a similar group. Department of Greek and Roman Antiquities, British Museum (Townley Drawings).

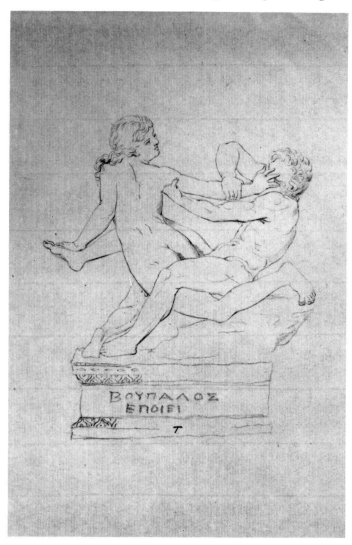

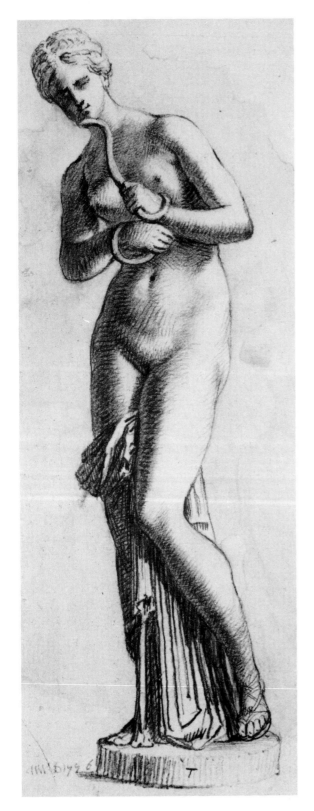

49 Drawing, initialled wwd 1776, of the statue of Venus shown in fig. 19 with a proposed restoration of the arms and hands holding a serpent. Department of Greek and Roman Antiquities, British Museum (Townley Drawings).

50 Drawing of the statue of Venus shown in fig. 19, perhaps by the sculptor Nollekens (1737–1823), who restored the arms. Department of Greek and Roman Antiquities, British Museum (Townley Drawings).

Townley must also have realised that the reclining satyr in his dining-room (fig.41, right foreground) was originally part of a group of a satyr struggling with a nymph, for he possessed a drawing of a complete version in the collection of his friend Henry Blundell (fig.48). Traces of the nymph's fingers remain on the satyr's face, and his left arm has been restored in a contorted attitude to meet them. This incongruous restoration, together with the other hand and both feet, was removed in the late nineteenth century, but the sculpture has recently been returned to its eighteenth-century appearance.

Most of Townley's damaged sculptures were restored in Rome, but the smaller of the two statues of Venus found at Ostia by Gavin Hamilton was brought to London still lacking both arms. The story of its restoration by Nollekens has been told by his pupil, John Thomas Smith. Smith was present when Townley met Nollekens in the street and commissioned him to restore the arms 'in various positions, such as holding a dove, the beak of which might touch her lips; entwining a wreath; or looking at the eye of a serpent'. The final result (fig.19) was a fairly conventional Venus *pudica*, for which Smith himself stood as model for the arms, but some of the alternatives proposed by Townley are represented by drawings in the Department of Greek and Roman Antiquities. The proposed restoration holding a snake is initialled wwd 1776 (fig.49). Another sketch (fig.50) was done on a scrap of paper left blank at the end of a letter; on the other side part of the address survives: '... Street Marybone'. Pointing out that Nollekens was resident in that part of London, John Kenworthy-Browne has suggested that this sketch of the restoration was made for Townley by Nollekens.

The Discus-thrower was restored in Italy. That the restoration is incorrect, with an alien head set at the wrong angle, is now well known. Townley himself was aware of the almost intact copy then in the Palazzo Massimi (now in the Museo Nazionale delle Terme, Rome), from which it is clear that in the original composition the athlete was looking back with his eye firmly on the discus. None the less, he persisted to the end of his life in maintaining that his version was not only correctly restored but was the best example: had it not served as a model for the restoration of the Vatican copy, which had been found without its head?

Townley was indeed a man of taste, but his judgement was not infallible. Like many of his generation he had been captivated by the conversation and speculative theories of d'Hancarville, and even when he no longer enjoyed d'Hancarville's society he continued to be influenced by his ideas. To the end of his life he accepted the title Periboeton for the two statues of a young satyr signed by Marcus Cossutius Cerdo, which Gavin Hamilton had excavated at Monte Cagnolo (fig.51). The name had been conferred on them by d'Hancarville, who had seen in them the character of Bacchus united with that of a satyr, and had mistakenly thought that Pliny's description of the Periboeton implied such a union: in fact, Pliny was referring to two seperate statues, and d'Hancarville's interpretation of the Latin text was remarkable more for ingenuity than accuracy.

In the same way Townley continued to adhere to d'Hancarville's

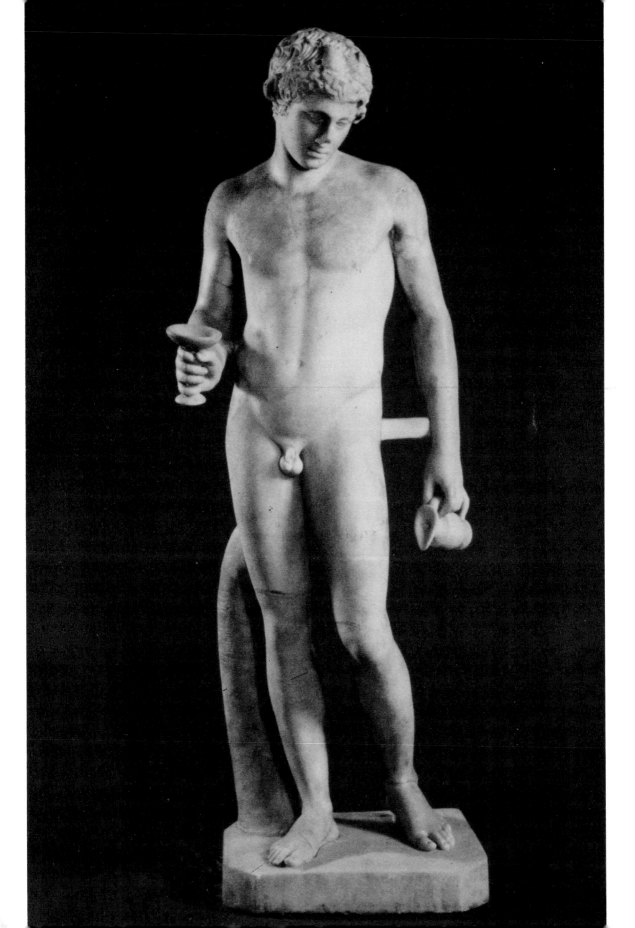

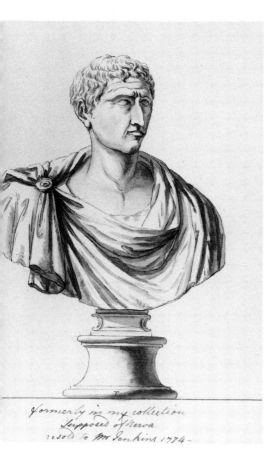

52 Drawing of a marble portrait identified as Nerva, bought by Townley in 1768 from Jenkins and returned to him in 1774. Department of Greek and Roman Antiquities, British Museum (Townley Drawings).

symbolic interpretation of ancient art. The catalogue he wrote around 1795 is full of examples. Of the relief showing Hercules and the deer he writes: 'The destruction of the Deer in this fable, as well as in that of the destruction of Acteon under the form of a deer, allude equally to the temporary dissolution or inaction of the generative spirit, personified by this animal and by Acteon.' In spite of an apology that 'The short compass of this catalogue will not allow a full relation of all the motives and principles, on which the various representations of the ancient deities, placed upon the waters, seem to be unfounded', his comments on 'Clytie' run to four pages, justifying in symbolic terms her description as 'Isis, placed upon the flower of the Lotus'.

Townley also made mistakes of a more mundane character. In his early days of collecting, when his enthusiasm inevitably outran his knowledge, he made a number of rather indiscriminate purchases that he later came to regret. Some of the portrait-busts for which he paid Jenkins on 12 August 1768 are represented by drawings in the British Museum with annotations like 'Formerly in my collection, supposed of Nerva, resold to Mr Jenkins 1774' (fig.52) and 'Bust supposed of Poppaea, size of life, given to Mr T. Astle 1783'. In 1778 he returned to Jenkins nine heads and busts, for which he had originally paid £250, in exchange for an allowance of £166. 13*s* towards the purchase price of £200 for the statue of Bacchus and the Vine (fig.58, right). Many other sculptures that appear in the early lists and notebooks are missing from the later records. Townley was evidently prepared to cut his losses in an effort to improve the overall quality of the collection.

In other respects the notebooks and catalogues provide no discernible evidence for a deliberate collecting policy. The actual choice of acquisitions seems to have been largely determined by what might be called economic factors—the availability of works to collect and the depth of the collector's pocket. Townley was willing to spend quite large sums on his collection. By about 1780 the second priced list in Preston gives the total cost of marbles as £7,521.5*s*. In a later account, undated but including a head acquired in 1795, this figure has risen to £10,997.12*s* with a further £4,400 for pictures, medals, books, gems and other antiquities. Availability was another matter. By the late eighteenth century no collector could seriously hope to rival the Papal and other collections in Rome, which had already been in existence for a couple of centuries or more. These collections had managed to acquire most of the really celebrated pieces of ancient sculpture, and important works like the Discus-thrower were seldom in the market as late as this.

The last years

In 1793, round about the time that the Discus-thrower arrived in London, Townley was elected to the Society of Dilettanti, a group of noblemen and gentlemen devoted impartially to patronage of the arts and the pleasures of the table. Among their projects was the publication, in sumptuous folio volumes, of engravings after ancient sculptures in various English collections, including Town-

ley's (*Specimens of Antient Sculpture*). The first volume did not actually appear until 1809, when Townley was already dead, but during the last years of his life he devoted much energy to the preparation of the plates. Among the Townley papers in the British Museum are a number of early proofs, as well as groups of duplicate prints in folders with comments like 'Duplicate impressions of some of the prints for the Dil: Soc, for self and not charged to the Society, but paid for by me' and 'Prints for the Dilettanti Society given me by Mr R. P. Knight, from 1801 to [date missing] as one of the committee'.

James Byres had left Rome in 1790 and Gavin Hamilton died in 1797. When Thomas Jenkins was expelled from Rome after the French occupied the city in 1798, the last of Townley's direct links with the city was broken. Jenkins had bought property in England some ten years previously, but he was not to enjoy the fruits of his dealings with Townley and other English collectors, for he died soon after landing at Yarmouth in 1798.

Very few of Townley's acquisitions can be dated later than this. Lord Cawdor died in 1800, and at the sale of his collection Townley bought a marble head of Apollo and perhaps also several marble feet that are not listed in any of the earlier documents on the collection. At the sale of the Bessborough collection in 1801 he bought a small grave relief showing a boy fishing, but this too went unrecorded in the catalogues and is shown to have belonged to Townley only by a drawing of it among the Townley papers in the British Museum.

New versions of the catalogue were still being produced. The Lancashire Record Office has two leather-bound volumes with many leaves watermarked 1800 or 1801. Volume 2 covers the library and the two drawing-rooms, and Volume 3 is devoted to the dining-room, so Volume 1 must have contained the hall, parlour and staircase. Among the sculptures that appear for the first time in Volume 3 are a terminal head of Bacchus and an entire terminus of Bacchus over 2 m high (fig. 53) They had been found together at Baiae near Naples in 1771 and had been purchased on the spot and brought to England by Dr Adair, after whose death Townley acquired them. Another newcomer among the sculptures in the dining-room is a Roman sarcophagus with the marriage of Cupid and Psyche, which had been brought from Rome by the Duke of St Albans. At the sale of the Duke's collection Townley also purchased a portrait of Sophocles, a head of Jupiter, two marble feet and a fluted cinerary urn that had once been in the Giustiniani collection in Rome.

Some entries for a more detailed catalogue on sheets watermarked 1802 and 1803 are preserved in the British Museum, but the last complete catalogue was compiled in 1804. Townley had it bound in two volumes, one for the hall, parlour, staircase and dining-room, the other for the library and the two drawing-rooms upstairs. In the preface he wrote: 'This catalogue indicates merely the places, where these marbles were discovered, or where they were formerly preserved, all comment upon them being avoided as likely to be tiresome to cursory spectators, for whose sole use this list has been made. 1804.'

Among the sculptures mentioned in the 1804 Parlour Catalogue

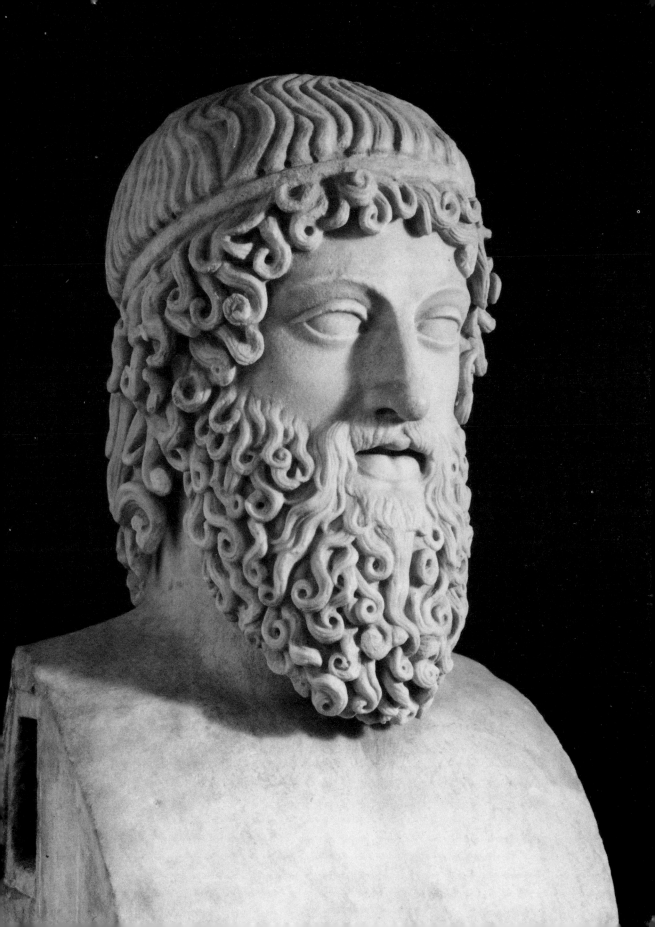

of which no trace has been found in earlier manuscripts are a basalt bust of Zeus Serapis, which had been acquired by Sir Robert Ainslie when he was Ambassador in Constantinople; a portrait-bust of the Emperor Antoninus Pius, said to have come from the Palazzo Barberini; a small relief of a cow and a calf; a fragmentary sarcophagus-front with an inscription to Marcus Sempronius Nicocrates; and the *cippus* of Viria Primitiva, which had been known since the fifteenth century and had been published more

54 Greek marble relief representing a man and two youths, presumably his sons, approaching Apollo and two standing goddesses, Leto and Artemis. The divinities are represented on a larger scale than the mortals. H. 50 cm. *BM Cat. Sculpture* 776.

recently in Cavaceppi's *Raccolta*. It is not known for certain when these sculptures were acquired by Townley. The sarcophagus of Nicocrates was engraved for him by Basire, and may therefore have been in the collection for some time.

The last sculpture to enter Townley's collection was a Greek votive relief presented to him by the Duke of Bedford (fig. 54). The relief is a Greek work of the fourth century BC but was later recut. The partial transformation of the worshippers' Greek civilian dress into Roman military uniform must be eighteenth-century work. Since Cavaceppi published the relief in his *Raccolta*, the restoration was presumably his. If Taylor Combe is correct in stating that it was given to Townley in 1805, he cannot have enjoyed it long, for he died on 3 January.

The Townley Marbles
in the British Museum

In his original will Townley had bequeathed his collection of marbles to the British Museum, to be exhibited in special rooms set aside for them. In the last years of his life, however, he was much occupied with plans for a sculpture gallery at his Lancashire house, Towneley Hall. Only twelve days before he died, he added a codicil to his will, leaving the collection first to his brother, Edward Townley Standish, and then to his uncle John Towneley, on con-

55 The British Museum in 1828. On the left is the north-west corner of Montagu House, with the Townley Gallery (opened in 1808) attached to it; on the right, part of the building designed by Sir Robert Smirke (now the northern part of the Egyptian Sculpture Gallery, with Greek and Roman rooms above). Watercolour by George Scharf. Department of Prints and Drawings, British Museum.

dition that a suitable building be erected for them either in Burnley or London. Failing this, the original terms of the will were to apply. John Towneley was very eager to see the marbles placed at Towneley Hall, but it seems that the necessary funds were not available. As a compromise the marbles were purchased by Act of Parliament for £20,000 and deposited in the British Museum.

The 1804 Parlour Catalogue was used as an inventory when the marbles were handed over to the Museum and the last page devoted to each room was signed:

> Ed∴ Townley Standish
> J. Planta Princ: Lib: Brit: Mus:
> T. Combe, a Librarian of the B.Museum.

Edward Townley Standish was the younger brother and heir of Charles Townley, who had generously made over to him during his own lifetime the Standish estate inherited from his mother.

At the time of Townley's death a new wing was being added to Montagu House to accommodate the Museum's growing collection of antiquities, including the Egyptian material captured from the French at Alexandria in 1801. Townley himself was a member of the Trustees' Subcommittee for the new gallery, and was strongly in favour of the simple Palladian style that was eventually adopted for the building, although some Trustees would have preferred to match the flamboyant French architecture of Montagu House itself (fig. 55). Although construction of the new gallery had already begun, work was temporarily suspended when the Townley marbles were bought so that the plans could be revised and some of the rooms made larger. The 'New Gallery' was eventually opened to the public in 1808 following a royal visit on 3 June.

The building was actually designed by George Saunders, the Trustees' Surveyor, but its interior decoration and the arrangement of the collection were entrusted to Henry Tresham, Professor of

56 The Townley Gallery seen from Room II with the Discus-thrower at the end of the vista. From *Ancient Marbles in the British Museum* Part I (1812).

Painting at the Royal Academy, and the sculptor Richard Westmacott. The contents of the various rooms are recorded in successive editions of the *Synopsis of the Contents of the British Museum*, initially compiled by Taylor Combe. The arrangement of the collection can be seen in contemporary engravings, including those published in Combe's more detailed account of the collection in *Ancient Marbles in the British Museum* (vols 1–3, 1812–17). While the sculptures were not grouped as they had been in Park Street,

the principle of symmetrical arrangements as practised by Townley was still strictly observed. Once again the Discus-thrower is to be seen at the end of a long vista (fig.56).

It had originally been intended that the Townley Gallery, as the new wing soon came to be called, should be the prototype for a series of extensions to Montagu House, but when the time for further building arrived tastes had changed. The now familiar neoclassical building designed by Sir Robert Smirke was eventually to replace both the Townley Gallery and Montagu House itself (fig.55). Demolition of the Townley Gallery began in 1846 and the sculptures gradually found new locations. By this time the reputation of the Roman sculptures and copies of Greek originals in the

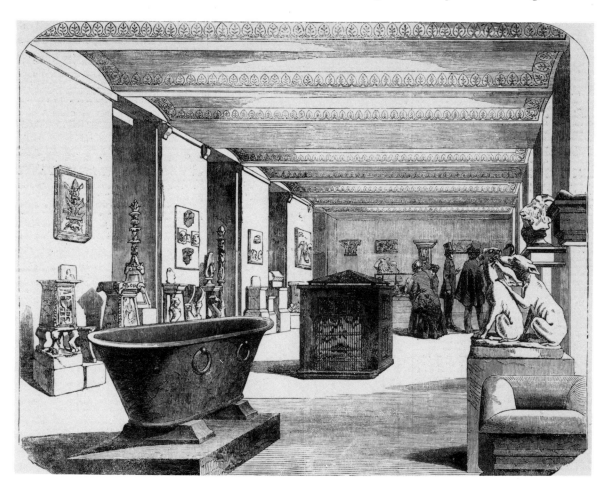

57 The 'Graeco-Roman Basement' in 1855 (after a woodcut in the *Illustrated London News*). More recently this room served as a public restaurant (closed in 1975).

Townley collection had declined following the Museum's acquisition of groups of original Greek works including the frieze from the temple of Apollo at Bassae (received in 1815), the Elgin Marbles (1816) and the sculptures from Xanthos (1842). Most of the Townley marbles came to be classified as 'Graeco-Roman' or 'sculptures of a mixed class, which, though dating from the period of the Roman Empire, and found chiefly in Italy, were executed generally by Greek artists, and in many instances copied, or but

58 The Townley Room in the Wolfson Galleries of Classical Sculpture and Inscriptions, opened in 1984.

slightly varied, from earlier Greek works', as they were described in the *Illustrated London News* of 26 May 1855, when the opening of a new gallery was announced as 'one of the attractive novelties to the Whitsuntide visitors' (fig.57).

From the opening of the original exhibition in 1808 other sculptures had been shown alongside the Townley marbles, and more and more were added as the Museum's collection grew. In consequence, although the Townley collection could still be described in 1904 as 'The nucleus of the Graeco-Roman series of sculptures in the Museum', it had long been impossible to describe any part of the Museum as 'The Townley Gallery', and this was to remain the case for another eighty years.

During the 1960s the galleries of the Department of Greek and Roman Antiquities on the ground floor of the British Museum were transformed. They had been built at intervals between 1831 and 1883 to accommodate the growing collection of sculpture, but in 1969 a new exhibition was opened, in which the development of Greek and Roman art could be followed from the beginning of the Bronze Age around 3000 BC to the Roman Empire. The displays, which included sculpture in bronze and terracotta as well as pottery, glass, jewellery and sealstones, displaced many of the stone sculptures formerly exhibited in these rooms, including most of the Townley collection. It was then intended that the storage basements beneath the Duveen Gallery should be converted into rooms for public exhibitions. Preparations began in 1971, and by the following year the Townley marbles were being assembled in the area allocated to them in the overall scheme. Although the reordering of the contents of the basements continued for some years, the structural changes and general redecoration required to convert the storerooms themselves into public galleries could not be undertaken for lack of funds until 1978, when a generous grant from the Wolfson Foundation allowed the scheme to go ahead. The Wolfson Galleries of Classical Sculpture and Inscriptions include the Townley Room, which was opened in 1984 (fig.58). While a few pieces have found appropriate places in other exhibition galleries, it is once again possible to see most of the Townley collection in one place and to form an impression of the taste and judgement that went into its formation.

References and further reading

*Items asterisked in the text have been contributed by Gerard Vaughan (see Preface).

A Catalogue of Sculpture in the Department of Greek and Roman Antiquities, British Museum (A. H. SMITH, 3 vols, 1890–1904, abbr. *BM Cat. Sculpture* in the captions). Most of the Townley marbles are included.

B. F. COOK, 'The Townley Marbles in Westminster and Bloomsbury', *British Museum Yearbook* 2 (1977), pp.34ff. Useful for references but not devoid of error.

FRANCIS HASKELL and NICHOLAS PENNY, *Taste and the Antique* (1981). A comprehensive survey of the historical and aesthetic context.

SEYMOUR HOWARD, *Bartolomeo Cavaceppi: Eighteenth-century Restorer* (1982). A 1958 doctoral dissertation, slightly outdated but still useful.

MICHAEL CLARKE and NICHOLAS PENNY, eds, *The Arrogant Connoisseur: Richard Payne Knight 1751–1824* (1982). Catalogue of an exhibition at the Whitworth Art Gallery, Manchester, with introductory essays containing much of interest on Townley and d'Hancarville.

FRANCIS HASKELL, 'The Baron d'Hancarville: an Adventurer and Art Historian in Eighteenth-century Europe', *Oxford, China and Italy, Essays in Honour of Harold Acton* (1984), pp.177ff. Modestly styled 'an introduction to the subject'.

SUSAN WALKER, *Memorials to the Roman Dead* (1985). Includes several items from the Townley collection in a survey of Roman burial customs and epitaphs.